POSTCARD HISTORY SERIES

# Santa Catalina Island

## IN VINTAGE POSTCARDS

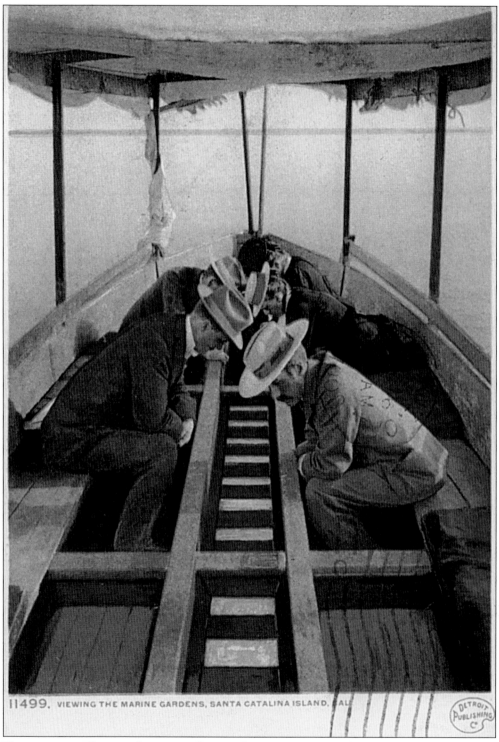

11499. VIEWING THE MARINE GARDENS, SANTA CATALINA ISLAND, CAL.

**VIEWING THE MARINE GARDENS, SANTA CATALINA ISLAND, CALIFORNIA.** (P/P: Detroit Publishing Co., No. 11499. Postmark: October 1908.)

POSTCARD HISTORY SERIES

# *Santa Catalina Island*

## IN VINTAGE POSTCARDS

Marlin L. Heckman

ARCADIA

First Printed 2001.
Reprinted 2004.

Published by Arcadia Publishing
Charleston SC, Chicago IL, Portsmouth NH, San Francisco CA

Printed in Great Britain.

Library of Congress Catalog Card Number: 00-110308

For all general information contact Arcadia Publishing at:
Telephone 843-853-2070
Fax 843-853-0044
E-Mail sales@arcadiapublishing.com
For customer service and orders:
Toll-Free 1-888-313-2665

Visit us on the internet at http://www.arcadiapublishing.com

# DEDICATION

*Dedicated to the Memory of my Father,*

*VERNON L. HECKMAN*

*1912–1969*

*who first took our family to Catalina Island in 1948*

*as he shared with us yet one more special place*

*in his native California.*

*Cover Image*: HOTEL METROPOLE, AVALON, SANTA CATALINA ISLAND, CALIFORNIA. With the beach at its door is Hotel Metropole, one of the finest to be found at any of the famous resorts in the world. (P/P: H.H.T. Co., No. 7664.)

# CONTENTS

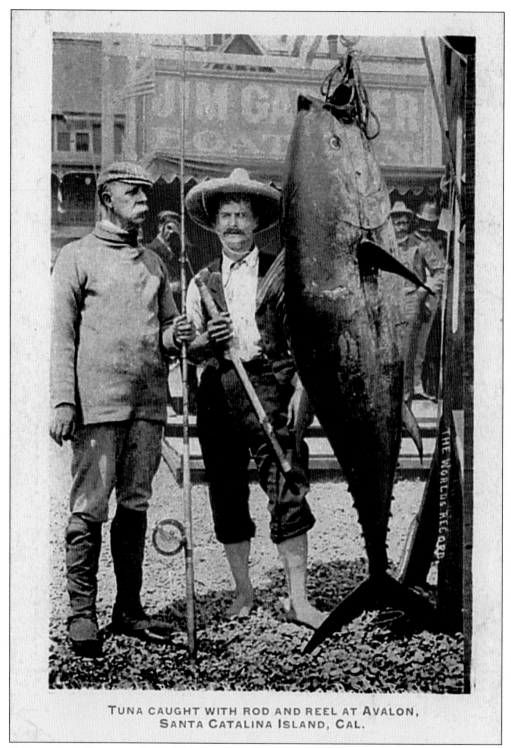

TUNA CAUGHT WITH ROD AND REEL AT AVALON, SANTA CATALINA ISLAND, CAL.

CAUGHT WITH ROD AND REEL, 384 POUNDS, SANTA CATALINA ISLAND, CALIFORNIA. (P/P: M. Rieder, Los Angeles. No. 514. Undivided back. Postmark: September 1907.)

# INTRODUCTION

Santa Catalina Island is a 76-square-mile island (some 50,000 acres), 20 miles off the Southern California coast. It is 22 miles in length, 8-miles wide, and is the third largest of the Channel Islands. Two thousand years ago the Gabrelino Native Americans called it the "mountain range in the sea." On a clear day Catalina is visible from high points of land in Los Angeles County.

Discovered by European sailors in 1542, it was named San Salvadore. Sixty years later, Viscaino rediscovered it and named it Santa Catalina. At the end of the Mexican-American War in 1848, Catalina Island became American territory. "In 1846 Governor Pio Pico granted the island to an American, Thomas Robbins. After changing hands several times Catalina was purchased by Phinneas Banning's three sons, who formed the Catalina Island Company in 1894 and turned the island into a resort. . . ."(Leonard and Dale Pitt, *Los Angeles A to Z*. Berkeley: University of California Press, 1997, p. 453.)

By the year 1871, "summer excursions to Santa Catalina by way of the Los Angeles and San Pedro Railroad to Wilmington and boat to the island first became popular with a limited number of people in Los Angeles. . . . A carrier pigeon service was inaugurated this year (1871), the birds taking about an hour to cross to or from the mainland. Racing of these birds was a popular sport, and one bird in that year is recorded as making the trip in fifty minutes." (John S. McGroarty, *History of Los Angeles County*. Chicago and New York, American Historical Society, 1923.)

After a devastating fire in 1915—which destroyed much of the city of Avalon—the Banning brothers had financial difficulties. Vacationing on Catalina in 1919, chewing gum magnate William Wrigley Jr. purchased a majority interest in the island and the Wilmington transportation company and began developments aimed at increasing tourist travel to Catalina. "Wrigley knew immediately what he did not want for the island. More than one biographer has quoted Wrigley's firmly stated doctrine—'There is to be nothing of the Coney Island flavor about Santa Catalina. It would not be thinkable to mar the beauty of such a spot with roller coasters and the like.'" (William Sanford White with Steven Kern Tice, *Santa Catalina Island, Its Magic, People and History*. Glendora, CA: White Limited Editions, 1997, p. 52.)

Around 1917, a dance pavilion had been built on Sugar Loaf Point. One thing William Wrigley Jr. did to improve tourist traffic involved the construction of additional hotel rooms and a casino, built in 1929 on the site of the former dance pavilion. It was

not a gambling casino but a 140-foot-tall circular building that included a dance floor on the upper level and a theater on the first floor. At the time of its construction, it was the tallest building in Los Angeles County. The theater seats 2,500 people. The casino was built on the site of the original dance pavilion. "The theater lobby alone is richly paneled with 4,500 square feet of black walnut, a hard wood that today costs about $6 a foot for any board narrower than nine inches. The auditorium walls are adorned by John Gabriel Beckman murals and highlighted by floodlights hidden behind a 7-foot wall." (Eric Noland, "Meet Me at the Casino." *Los Angeles Times*, May 14, 2000, p. D3.) "For the night of the grand opening, May 29, 1929, a full program of activities were scheduled for the casino. The just released film, *The Iron Mask*, starring Douglas Fairbanks, Belle Bennett, and Dorothy Revier was showing at the theater. In the ballroom, thousands glided across the vast dance floor. The *Los Angeles Times* reported 'the gala opening of the $2,000,000 casino. . . brought to this paradise isle ten thousand pre-holiday visitors.'" (White, *Santa Catalina Island*, 1997, p. 134.) Before and after World War II, thousands of people arrived in Avalon, Catalina's only city, by boat each summer to enjoy life on the island. Mr. Wrigley owned the Chicago Cubs baseball team, and for many years the team held its spring training camp on Catalina Island.

Over the years, visitors to the island have been able to take tours enjoying the undisturbed areas further inland. In early years, the mode of transportation was horse-drawn wagon. Today there are special tour buses. Buffaloes, left behind from a movie shoot, still roam on parts of Catalina. A bird sanctuary shows off many varieties of species. The steel frame of the bird sanctuary was originally the framework of the dance pavilion. Glass-bottom boats have shown visitors the beauties of the submarine gardens for many decades. Today scuba divers also enjoy the underwater areas off the Catalina shoreline. Many private yachts and boats are to be found at anchor in Avalon Bay during the summer season.

For more than one hundred years, Santa Catalina Island has been referred to by many as an island paradise. Today it is considered to be one of the world's great ecological treasures. Since the mid-1970s, about 85 percent of the land on Catalina has been deeded to the Catalina Conservancy.

The town of Avalon and Avalon Bay are said to have been named for a mythical island in Tennyson's poem *Idylls of the King*. ". . . Where fall not hail or rain, or any snow, nor ever wind blows loudly. . ." Catalina enjoys 267 sunny days each year and has an average rainfall of 14 inches.

# One

# CATALINA ISLAND AND ITS HARBOR AT AVALON

Avalon, Santa Catalina Island, Cal.

**AVALON, SANTA CATALINA ISLAND, CALIFORNIA.** (P/P: M. Rieder, Los Angeles. No. 1502. Made in Germany. Undivided back. Postmark: July 1905.)

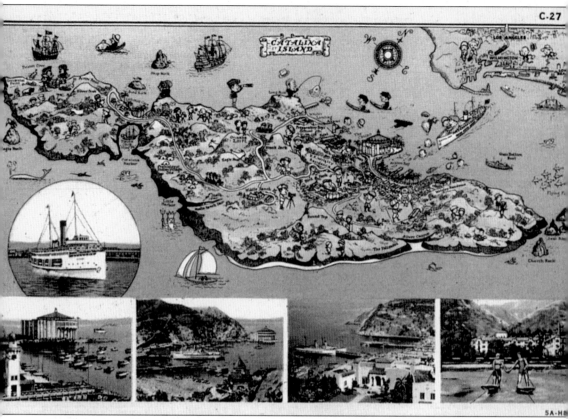

**CATALINA ISLAND [MAP].** (P/P: Western Publishing and Novelty Co., Los Angeles. No. C-27.)

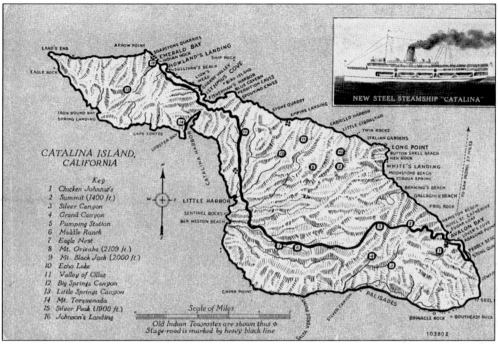

CATALINA ISLAND, CALIFORNIA [MAP]. (P/P: C.T., Chicago. No. 103802. Dated July 1935.)

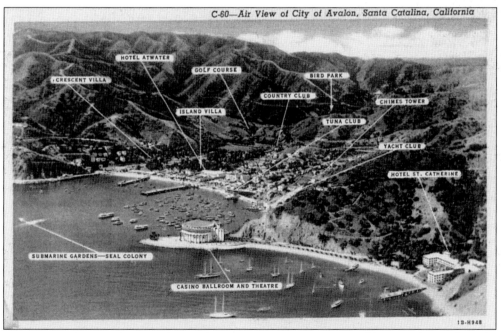

AIR VIEW OF CITY OF AVALON, SANTA CATALINA ISLAND, CALIFORNIA. Text on the card reads, "Nestling in the shelter of the surrounding hills, the town of Avalon presents a busy scene of beach, business streets, hotels, and attractive bungalows. Like some foreign city, Avalon climbs back into the hills, looking down on the Bay and yachts at harbor." (P/P: Western Publishing and Novelty Co., Los Angeles. No. C-60.)

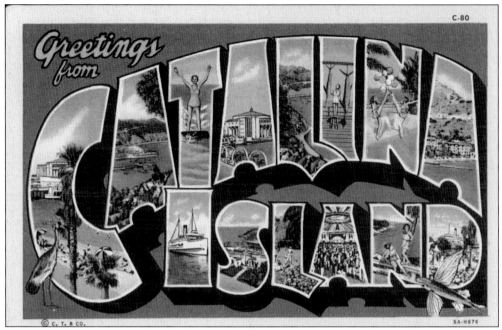

**GREETINGS FROM CATALINA ISLAND**. (P/P: Western Publishing and Novelty, Los Angeles. No. 80. Purchased July 1941.)

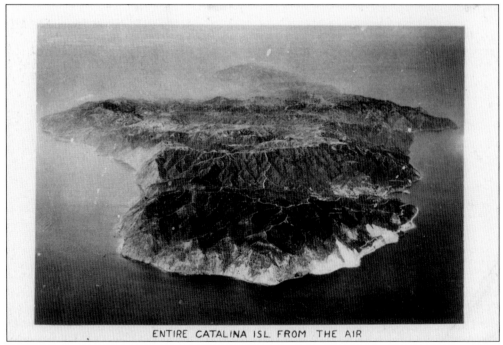

ENTIRE CATALINA ISL. FROM THE AIR

**ENTIRE CATALINA ISLAND FROM THE AIR**. (P/P: Unknown.)

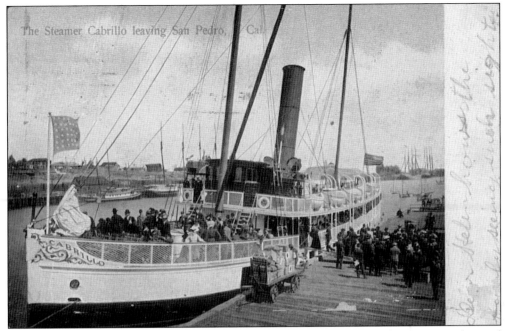

**The Steamer** *Cabrillo* **leaving San Pedro, California.** (P/P: M. Rieder, Los Angeles and Leipzig. No. 3294. Postmark: October 1906.)

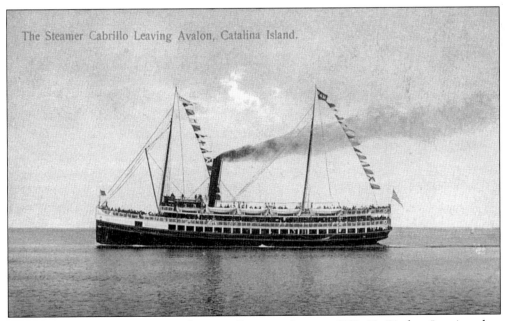

**The Steamer** *Cabrillo* **leaving Avalon, Catalina Island.** (P/P: M. Rieder, Los Angeles. No. 3275. Made in Germany.)

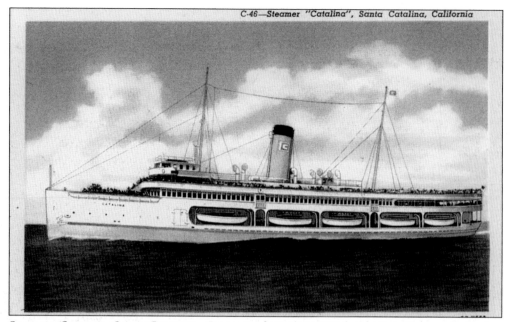

STEAMER *CATALINA*, SANTA CATALINA, CALIFORNIA. Built in 1924, the *Catalina* made its last run in 1976. Text on the card reads, "Roomy, comfortable, ocean-going steamships cruise daily to Santa Catalina from the Mainland. A delightful voyage, leaving from Los Angeles Harbor at Wilmington and making the crossing in two hours—then following the shoreline past bays and coves until beautiful Avalon is reached. (P/P: Western Publishing and Novelty Co., Los Angeles. No. C 46.)

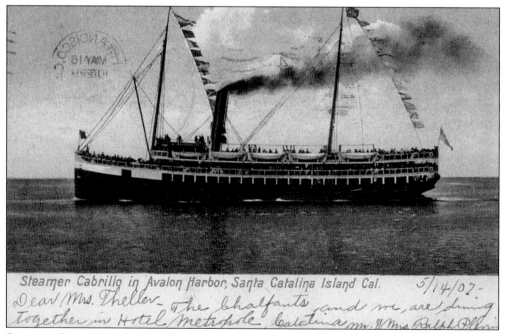

STEAMER *CABRILLO* IN AVALON HARBOR, SANTA CATALINA ISLAND, CALIFORNIA. (P/P: Newman Post Card Co., Los Angeles. No. 4527. Made in Germany. Postmark: May 16, 1907.)

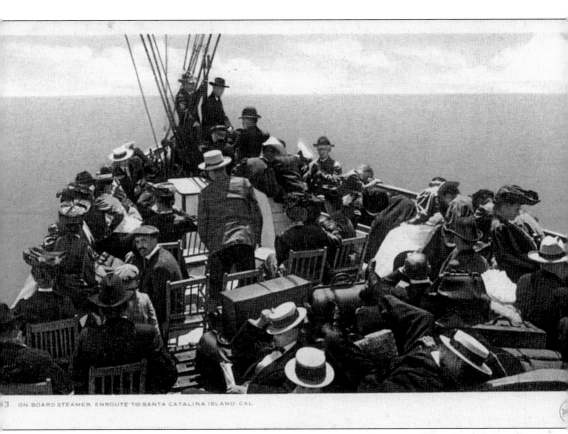

**ON BOARD STEAMER ENROUTE TO SANTA CATALINA ISLAND, CALIFORNIA.** (P/P: Detroit Publishing Co. No. 11243.)

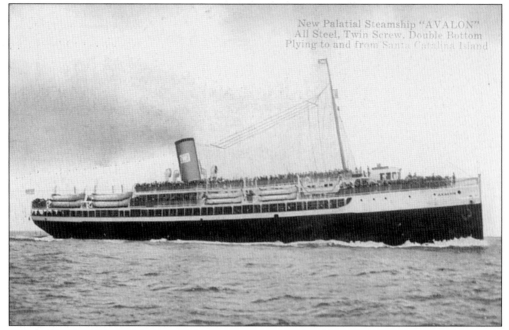

**NEW PALATIAL STEAMSHIP *AVALON*: ALL STEEL, TWIN SCREW, DOUBLE BOTTOM; PLYING TO AND FROM SANTA CATALINA ISLAND.** The *S.S. Avalon* was retired from service in 1951. (P/P: Van Ornum Colorprint, Los Angeles.)

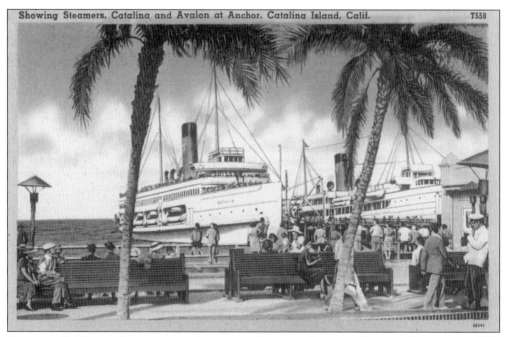

**SHOWING STEAMERS *CATALINA* AND *AVALON* AT ANCHOR, CATALINA ISLAND, CALIFORNIA.** (P/P: Tichnor Art Co., Los Angeles. No. T 558.)

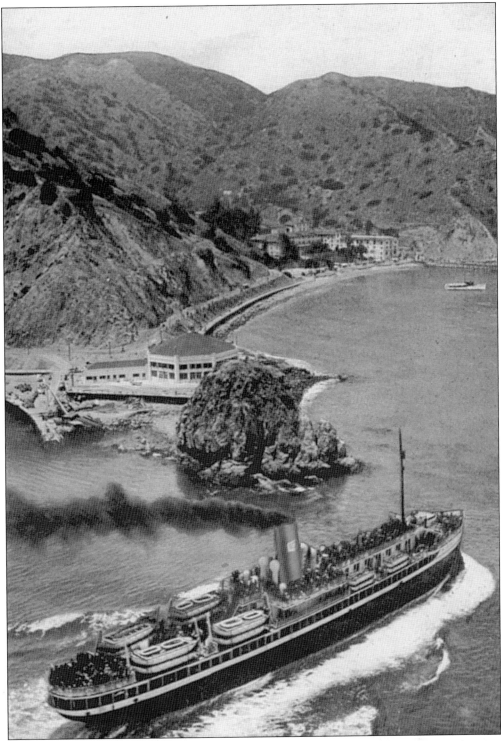

**STEAMSHIP** *AVALON*, **SUGAR LOAF ROCK CASINO AND HOTEL ST. CATHERINE, CATALINA ISLAND, CALIFORNIA.** (P/P: Van Ornum Colorprint, Los Angeles.)

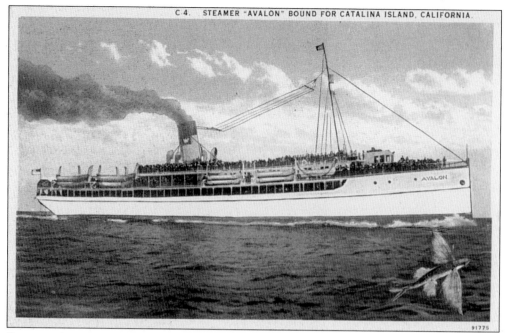

**STEAMER** *AVALON* **BOUND FOR CATALINA ISLAND, CALIFORNIA.** A flying fish is shown in the right corner. (P/P: Western Publishing and Novelty Co., Los Angeles. No. C4.)

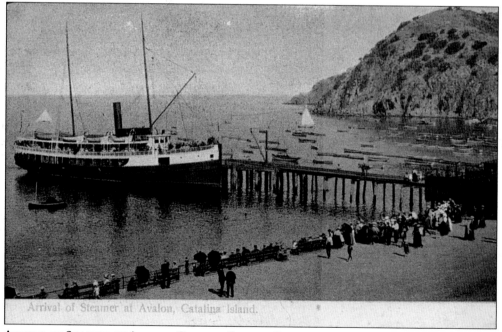

*Arrival of Steamer at Avalon, Catalina Island.*

**ARRIVAL OF STEAMER AT AVALON, CATALINA ISLAND, CALIFORNIA.** (P/P: M. Rieder, Los Angeles and Leipzig. No. 3000.)

18

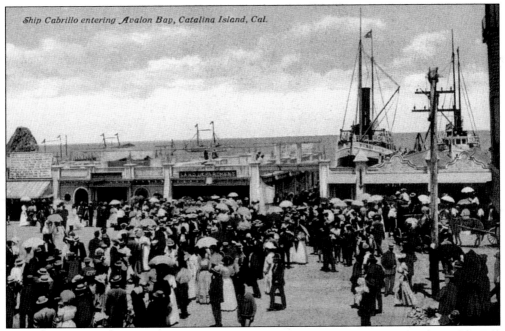

**Ship _Cabrillo_ entering Avalon Bay, Catalina Island, California.** (P/P: Benham Co., Los Angeles. No. A11812.)

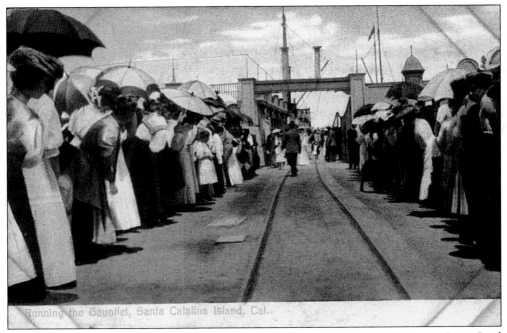

**Running the Gauntlet, Santa Catalina Island, California.** (P/P: Newman Post Card Co., Los Angeles. No. E9. Made in Germany.)

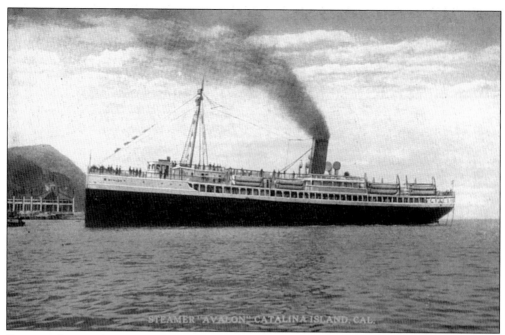

STEAMER *AVALON* CATALINA ISLAND, CALIFORNIA. (P/P: Catalina Novelty Co., Catalina Island, CA.)

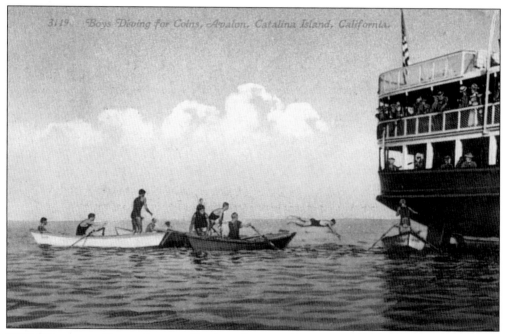

BOYS DIVING FOR COINS, AVALON, CATALINA ISLAND, CALIFORNIA. (P/P: Edward H. Mitchell, San Francisco. No. 3119.)

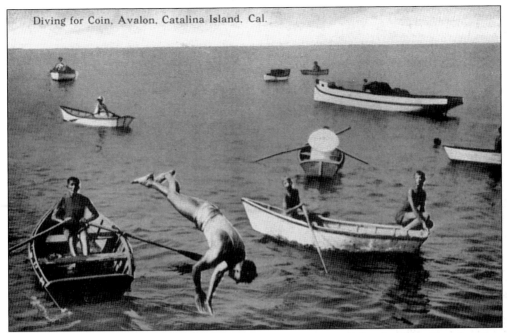

**DIVING FOR COIN, AVALON, CATALINA ISLAND, CALIFORNIA.** (P/P: Catalina Novelty Co., Catalina Island, CA. No. 44104.)

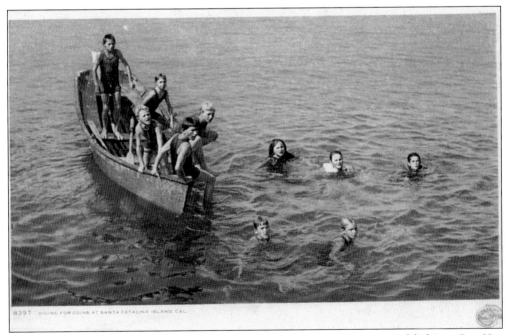

**DIVING FOR COINS AT CATALINA ISLAND, CALIFORNIA.** (P/P: Detroit Publishing Co. No. 8397.)

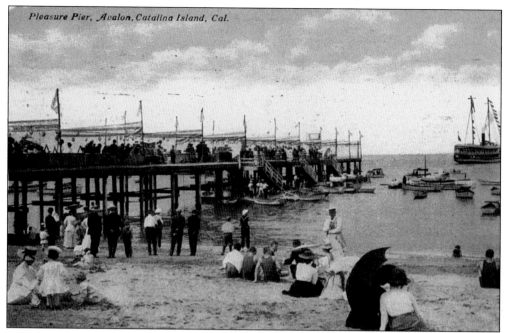

**PLEASURE PIER, AVALON, CATALINA ISLAND, CALIFORNIA.** (P/P: Benham Co., Los Angeles. No. 2855. Postmark: August 1913.)

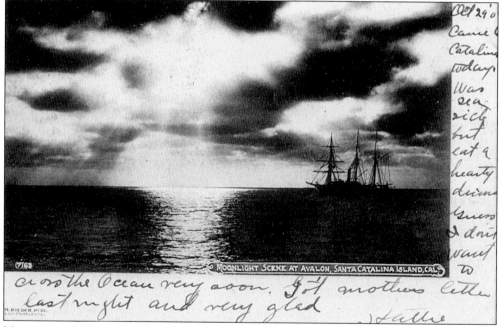

**MOONLIGHT SCENE AT AVALON, CATALINA ISLAND, CALIFORNIA.** (P/P: M. Rieder, Los Angeles. No. 7163. Undivided back. Postmark: October 1904.)

22

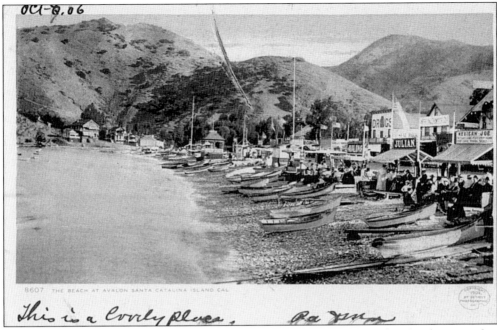

**THE BEACH AT AVALON, SANTA CATALINA ISLAND, CALIFORNIA.** (P/P: Detroit Photographic Co. Copyright 1904. No. 8607. Undivided back. Postmark: October 1906.)

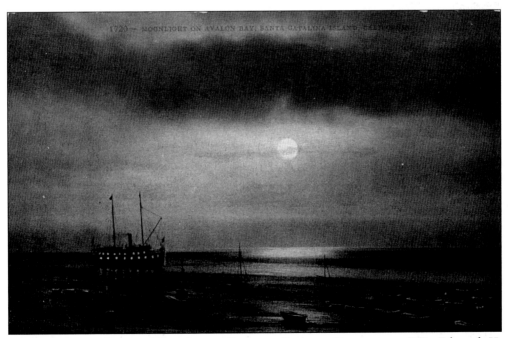

**MOONLIGHT ON AVALON BAY, SANTA CATALINA ISLAND, CALIFORNIA.** (P/P: Edward H. Mitchell, San Francisco. No. 1720.)

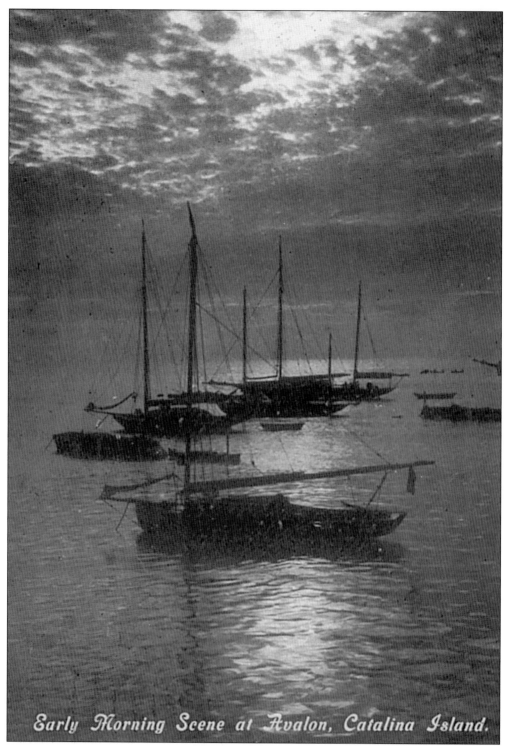

Early Morning Scene at Avalon, Catalina Island.

**EARLY MORNING SCENE AT AVALON, CATALINA ISLAND.** (P/P: O. Newman Co., Los Angeles and San Francisco. No. E37. Postmark: August 1913.)

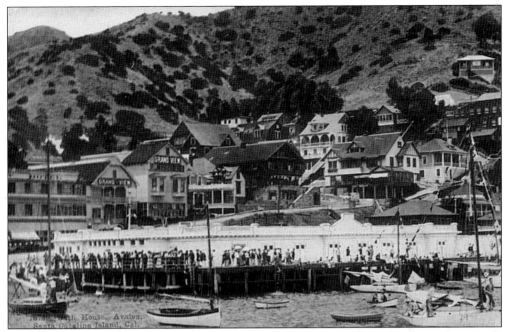

**BATH HOUSE, AVALON, SANTA CATALINA ISLAND, CALIFORNIA.** Text on the card reads, "Bathing at Catalina is especially delicious in the beautiful transparent water and is a favorite pastime with young and old." (P/P: H.H.T. No. 7674.)

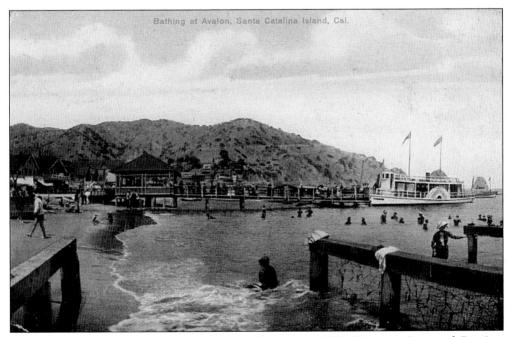

**BATHING AT AVALON, SANTA CATALINA ISLAND, CALIFORNIA.** (P/P: Newman Postcard Co., Los Angeles. No. E25. Postmark: September 1910.)

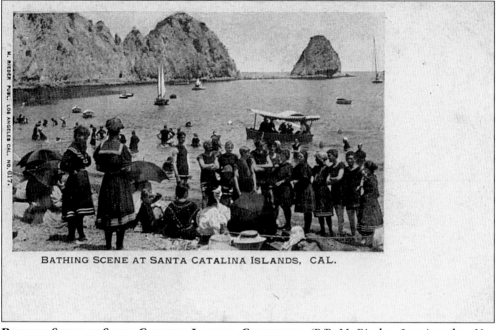

**BATHING SCENE AT SANTA CATALINA ISLANDS, CALIFORNIA.** (P/P: M. Rieder, Los Angeles. No. 617. Undivided back.)

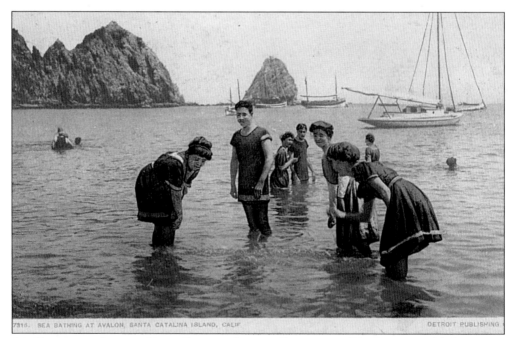

**SEA BATHING AT AVALON, SANTA CATALINA ISLAND, CALIFORNIA.** (P/P: Detroit Publishing Co., No. 7316.)

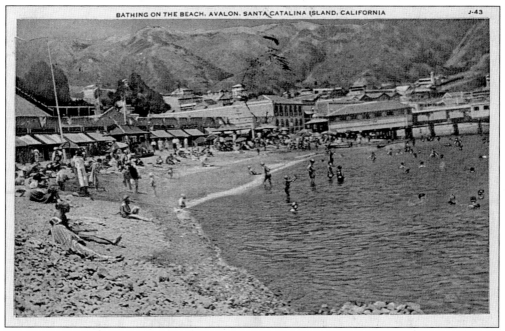

**BATHING ON THE BEACH, AVALON, SANTA CATALINA ISLAND, CALIFORNIA.** (P.P: Pacific Novelty Co., San Francisco. No. J43. Postmark: August 1931.)

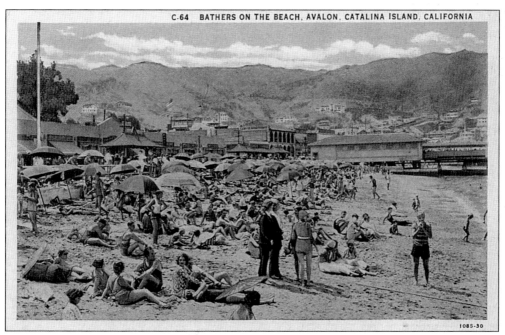

**BATHERS ON THE BEACH, AVALON, CATALINA ISLAND, CALIFORNIA.** (P/P: Western Publishing and Novelty Co., Los Angeles. No. C64.)

**GREETINGS FROM CATALINA ISLAND.** The message on the card reads, ". . . We children have had two delightful baths [ocean]. In fact are having a fine time in general. Let us hear about your troubles soon. Lovingly, Nellie, Tent 9 Block O, Sixth St. (P/P: M. Rieder, Los Angeles. No. 157. Made in Germany. Postmark: August 1905.)

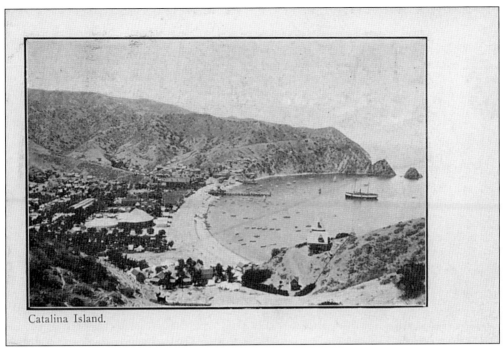

Catalina Island.

**CATALINA ISLAND.** (P/P: J.T. Sheward, Los Angeles. Undivided back.)

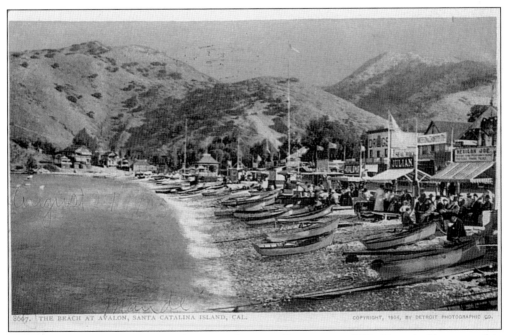

8607. THE BEACH AT AVALON, SANTA CATALINA ISLAND, CAL.　　COPYRIGHT, 1904, BY DETROIT PHOTOGRAPHIC CO.

**THE BEACH AT AVALON, SANTA CATALINA ISLAND, CALIFORNIA.** (P/P: Detroit Photographic Co. Copyright 1904. No, 8607. Postmark: August 1905. Undivided back.)

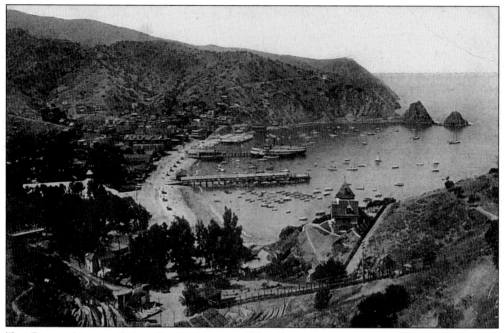

**THE BAY OF AVALON, SANTA CATALINA ISLAND.** Text from the card reads, "California's most popular winter and Summer Resort. Particularly famous for its wonderful sea angling, beautiful marine gardens and remarkable dry marine climate. Boating, bathing, golf, tennis, mountain coaching, wild goat hunting." (P/P: The Neuner Co., Los Angeles. Copyright: Baker Photo Co.)

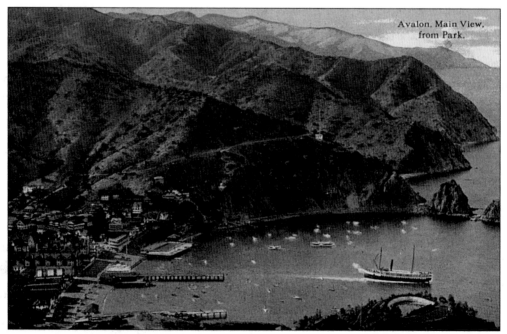

**AVALON. MAIN VIEW FROM PARK.** (P/P: Catalina Novelty Co., Catalina Island, CA. No. R 51316. Postmark: July 1921.)

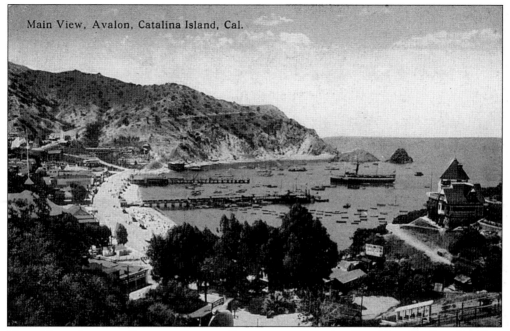

Main View, Avalon, Catalina Island, Cal.

**MAIN VIEW, AVALON, CATALINA ISLAND, CALIFORNIA.** (P/P: Catalina Novelty Co., Catalina Island. Copyright: P.V. Reyes. No. A 69271. Postmark: August 1921.)

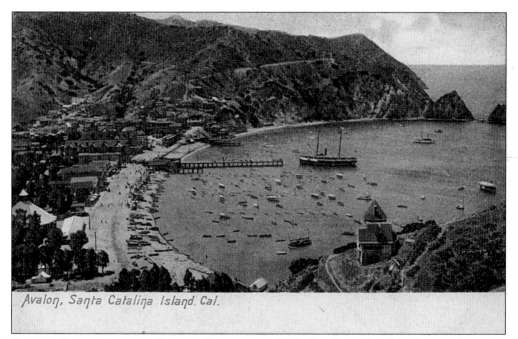

Avalon, Santa Catalina Island. Cal.

**AVALON, SANTA CATALINA ISLAND, CALIFORNIA.** (P/P: Catalina Novelty Co., Avalon, CA. Made in Germany. Postmark: August 1908.)

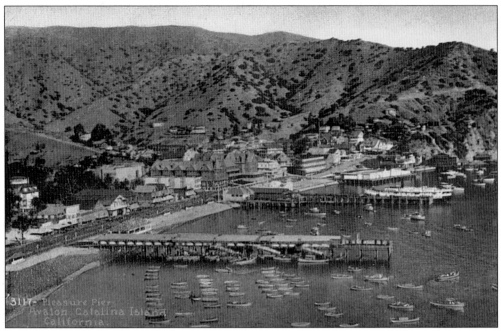

**PLEASURE PIER, AVALON, CATALINA ISLAND, CALIFORNIA.** (P/P: Edward H. Mitchell Co., San Francisco. No. 3117.)

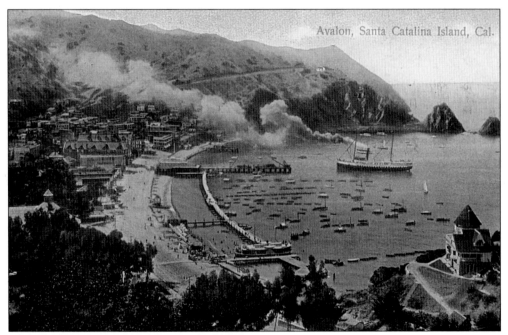

**AVALON, SANTA CATALINA ISLAND, CALIFORNIA.** (P/P: M. Rieder, Los Angeles. No. 5295. Made in Germany. Postmark: January 1911.)

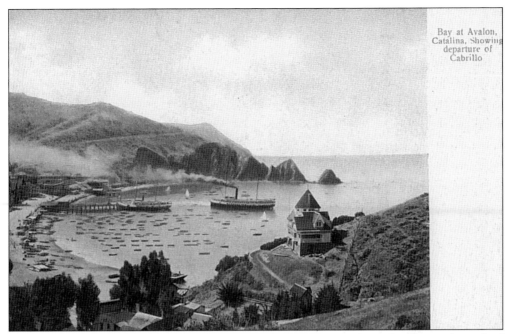

**BAY AT AVALON, CATALINA, SHOWING DEPARTURE OF *CABRILLO*.** The *Cabrillo* was launched in 1904. (P/P: M. Rieder, Los Angeles and Leipzig. No. 3309.)

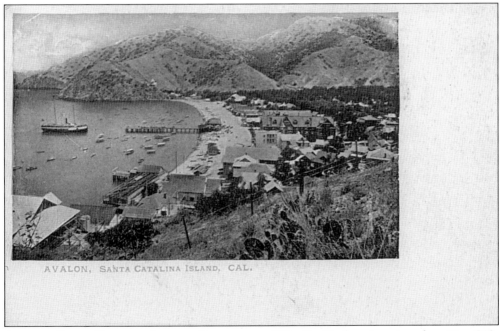

**AVALON, SANTA CATALINA ISLAND, CALIFORNIA.** (P/P: M. Rieder, Los Angeles. No. 513. Undivided back.)

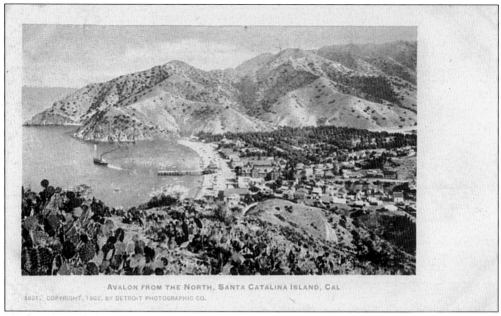

**AVALON FROM THE NORTH, SANTA CATALINA ISLAND, CALIFORNIA.** (P/P: Detroit Photographic Co., Copyright: 1902. No. 5831. Undivided back. Private Mailing Card.)

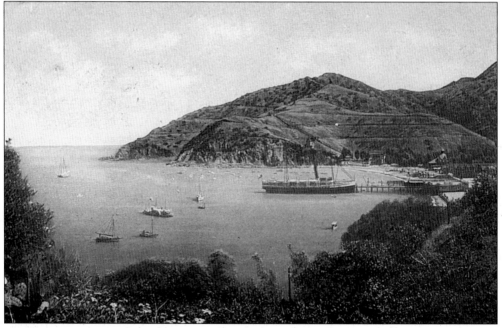

**AVALON, CATALINA ISLAND FROM WIRELESS TELEGRAPHY STATION.** (P/P: M. Rieder, Los Angeles. No. 3696. Made in Germany. Postmark: June 1913.)

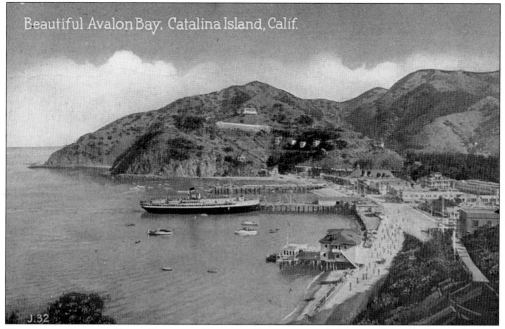

BEAUTIFUL AVALON BAY, CATALINA ISLAND, CALIFORNIA. (P/P: Pacific Novelty Co., San Francisco and Los Angeles. No. J32.)

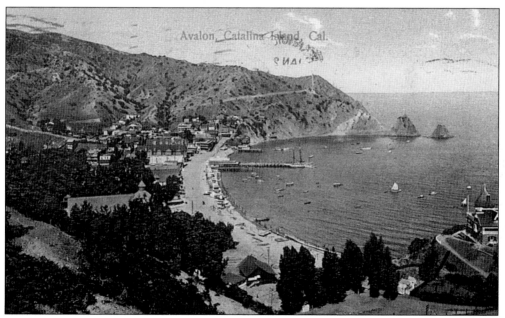

AVALON, CATALINA ISLAND, CALIFORNIA. (P/P: M. Rieder, Los Angeles. No. 4765. Made in Germany. Postmark: January 1908.)

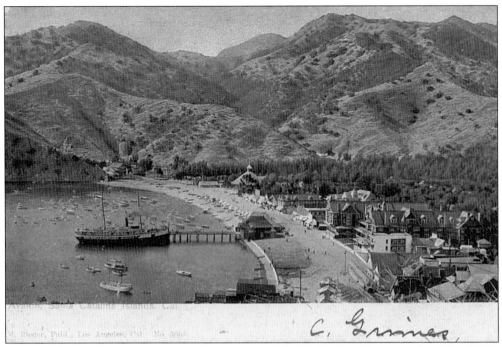

**AVALON, SANTA CATALINA ISLANDS, CALIFORNIA.** (P/P: M. Rieder, Los Angeles. No. 3007. Undivided back. Postmark: May 1904.)

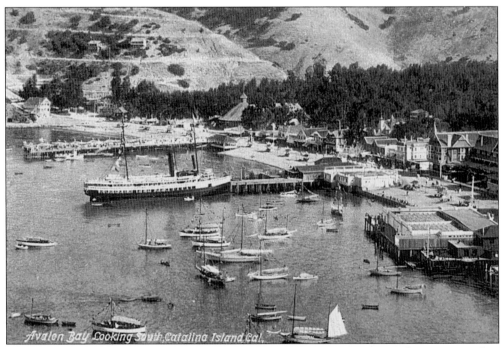

**AVALON BAY LOOKING SOUTH, CATALINA ISLAND, CALIFORNIA.** (P/P: M. Rieder, Los Angeles. No. 5408. Made in Germany.)

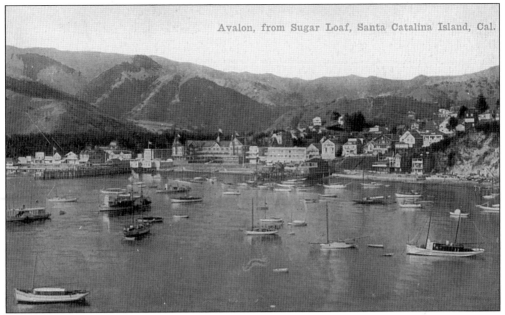

**AVALON, FROM SUGAR LOAF, SANTA CATALINA ISLAND, CALIFORNIA.** (P/P: Souvenir Publishing Co., Los Angeles and San Francisco. No. E33.)

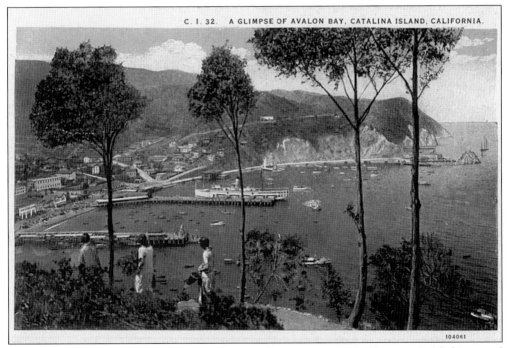

**A GLIMPSE OF AVALON BAY, CATALINA ISLAND, CALIFORNIA.** (P/P: Western Publishing and Novelty Co., Los Angeles. No. CI32.)

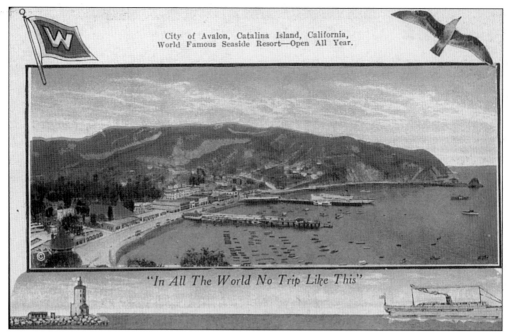

CITY OF AVALON, CATALINA ISLAND, CALIFORNIA. Text on the card reads, "World Famous Seaside Resort—open all year. In All the World no Trip Like This." (P/P: E.C. Kropp, Milwaukee. No. 29299.)

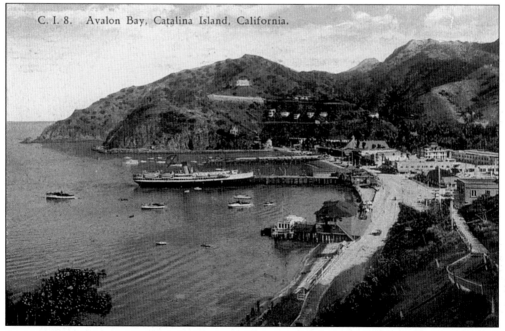

AVALON BAY, CATALINA ISLAND, CALIFORNIA. The message on the card reads, "Came in 3 pm Friday. Had to use motor all the way. No wind. Water as smooth as pond. Sleep fine on boat. Fine sailing today. Cross shows where we anchor." (P/P: Western Publishing and Novelty Co., Los Angeles. No. CI8. Postmark: June 1924.)

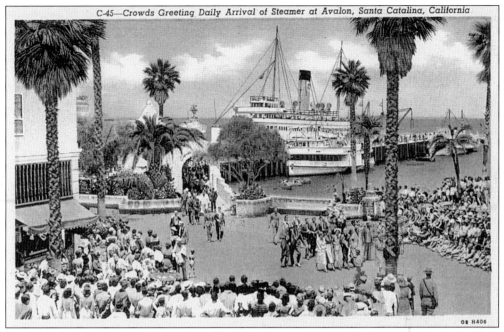

CROWDS GREETING DAILY ARRIVAL OF STEAMER *AVALON*, SANTA CATALINA, CALIFORNIA. Text on the card reads, "Welcoming crowds gather to greet the daily arrivals from the mainland with cheerful songs and laughter. In *Avalon's* gaily tiled Fountain Plaza, with its bowers of Palm and Olive trees, and the soft music of the troubadours, it is a place where the realism of everyday life becomes suddenly unimportant. It is a place to play, to dream, to let the rest of the world go by." (P/P: Western Publishing and Novelty Co., Los Angeles. No. C45.)

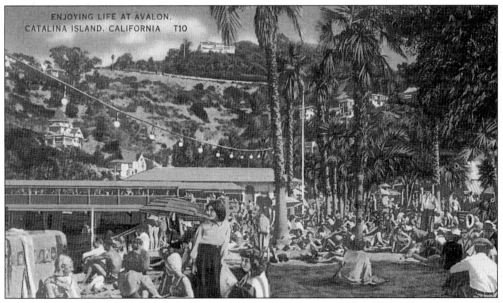

ENJOYING LIFE AT AVALON, CATALINA ISLAND, CALIFORNIA. (P/P: Tichnor Art. Co., Los Angeles. No. T10.)

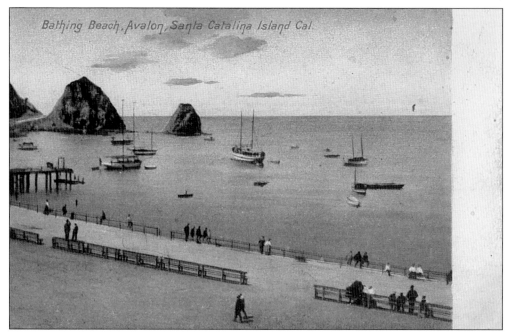

**BATHING AT BEACH AVALON, SANTA CATALINA ISLAND, CALIFORNIA.** (P/P: Catalina Novelty Co., Avalon, CA. Made in Germany.)

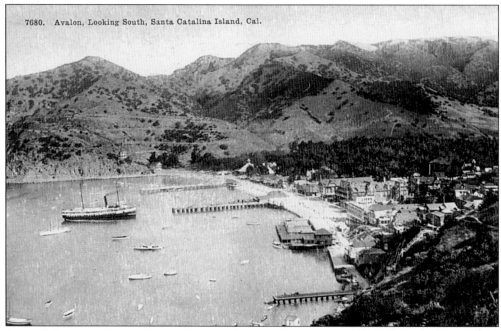

**AVALON, LOOKING SOUTH, SANTA CATALINA ISLAND, CALIFORNIA.** (P/P: Unknown. No. 7680.)

# *Two*
# HOTELS, RESIDENCES, AND TENT CITY

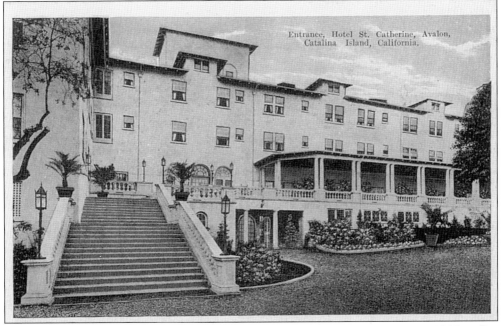

**ENTRANCE, HOTEL ST. CATHERINE, AVALON, CATALINA ISLAND, CALIFORNIA.** In 1915, a fire ravaged Avalon, burning for three days. The St. Catherine was built in 1918. (P/P: Catalina Postcard Co., Los Angeles. No. 25239.)

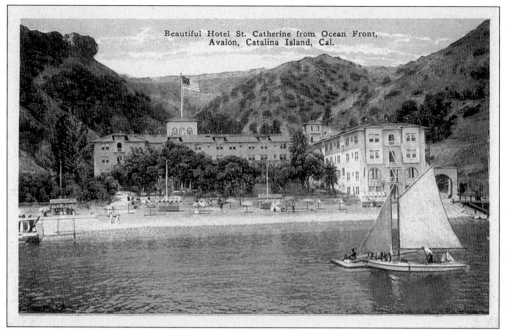

**BEAUTIFUL HOTEL ST. CATHERINE FROM OCEANFRONT, AVALON, CATALINA ISLAND, CALIFORNIA.** (P/P: E.C. Kropp, Milwaukee. No. 30972N.)

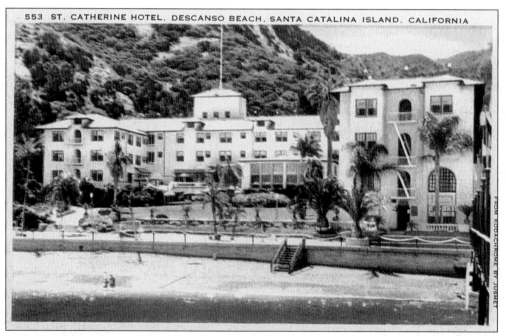

**ST. CATHERINE HOTEL, DESCANSO BEACH, SANTA CATALINA ISLAND, CALIFORNIA.** Text on the card reads, "The luxurious Hotel St. Catherine, surrounded by colorful gardens on Descanso Beach (meaning 'rest') is open the year round, and offers many delightful diversions to its guests." (P/P: Longshaw Card Co., Los Angeles. No. 553.)

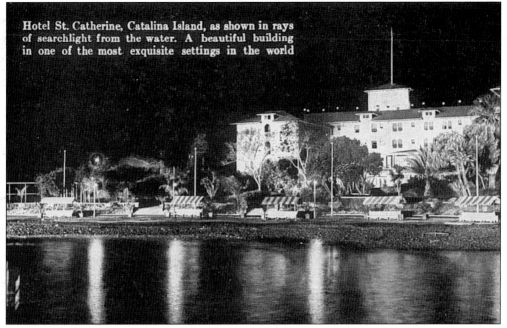

Hotel St. Catherine, Catalina Island, as shown in rays
of searchlight from the water. A beautiful building
in one of the most exquisite settings in the world

HOTEL ST. CATHERINE, CATALINA ISLAND, AS SHOWN IN RAYS OF SEARCHLIGHT FROM THE
WATER. This is a beautiful building in one of the most exquisite settings in the world.
(P/P: Quadricolor Press, Los Angeles.)

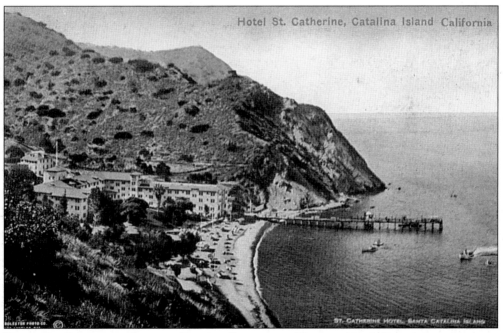

Hotel St. Catherine, Catalina Island California

HOTEL ST. CATHERINE, CATALINA ISLAND, CALIFORNIA. The hotel had dining space to serve
1,200 people. (P/P: Pacific Novelty Co., San Francisco. No. J3. Copyright: Huddleston
Photo Co., Los Angeles.)

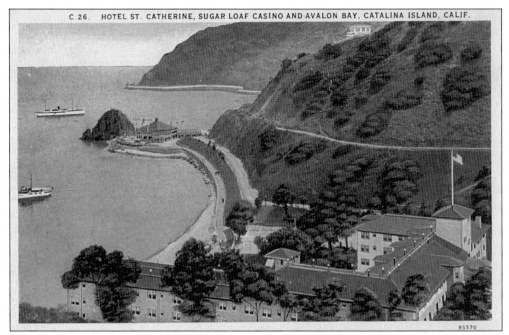

**HOTEL ST. CATHERINE, SUGAR LOAF CASINO, AND AVALON BAY, CATALINA ISLAND, CALIFORNIA.**
(P/P: Western Publishing & Novelty Co., Los Angeles. No. C26.)

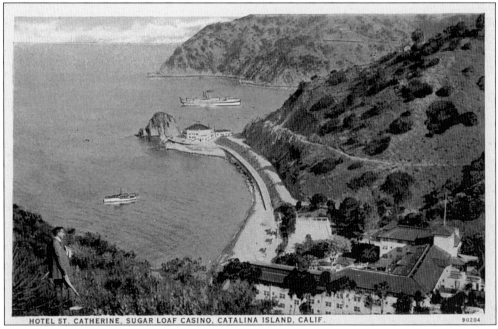

**HOTEL ST. CATHERINE, SUGAR LOAF CASINO, CATALINA ISLAND, CALIFORNIA.** (P/P: Island
Pharmacy, Avalon, Catalina Island, CA. No. 90204.)

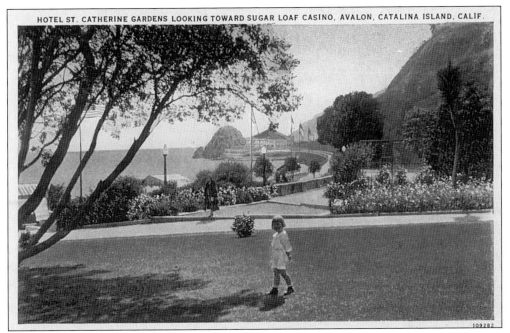

HOTEL ST. CATHERINE GARDENS LOOKING TOWARD SUGAR LOAF CASINO, AVALON, CATALINA ISLAND, CALIFORNIA. (P/P: C.T., Chicago. No. 109282.)

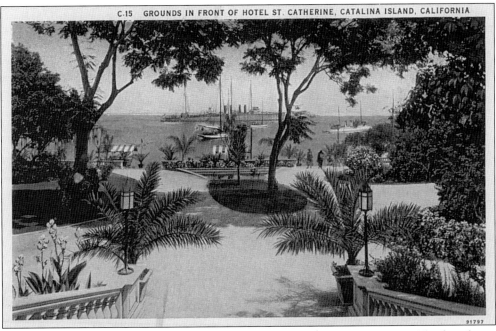

GROUNDS IN FRONT OF HOTEL ST. CATHERINE, CATALINA ISLAND, CALIFORNIA. The hotel was demolished in 1965. (P/P: Western Publishing and Novelty Co., Los Angeles. No. C15.)

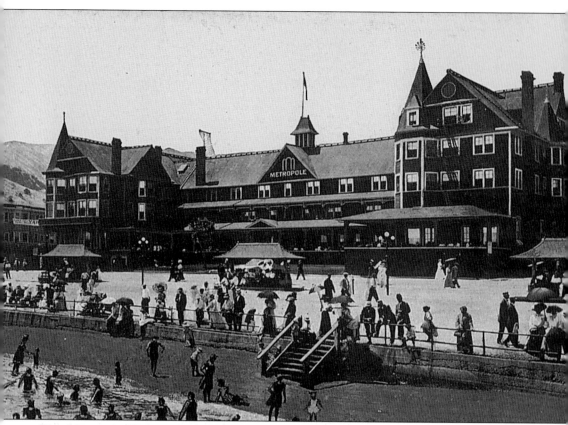

THE METROPOLE HOTEL, AVALON. Text on the card reads, "The Metropole Hotel, Avalon, Santa Catalina Island. A high-class hotel, conducted on the European plan. Reasonable rates. Excellent cafe. Good service. Let us send illustrated literature, and tell you about the remarkable dry marine climate (average annual range of temperature less than 13 degrees) of this beautiful resort." (P/P: Neuner Co., Los Angeles.)

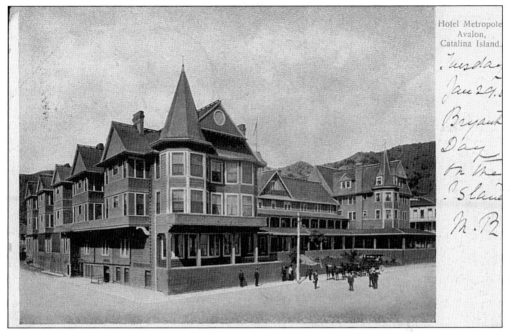

**HOTEL METROPOLE, AVALON, CATALINA ISLAND.** The first hotel on the island, it was originally built in 1887. (P/P: M. Rieder, Los Angeles 7 Leipzig. No. 3486. Postmark: January 1907.)

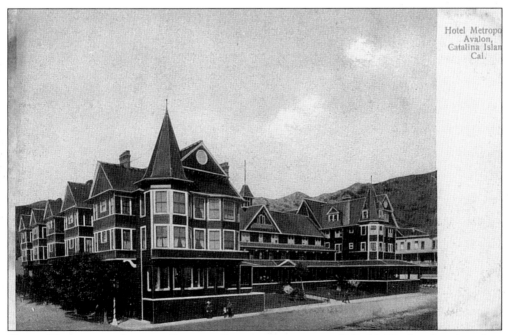

**HOTEL METROPOLE, AVALON, CATALINA ISLAND, CALIFORNIA.** (P/P: M. Rieder, Los Angeles. No. 3497. Made in Germany.)

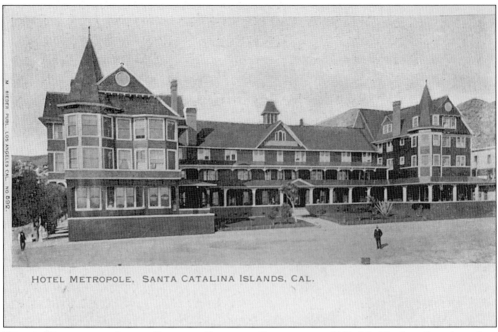

**HOTEL METROPOLE, SANTA CATALINA ISLANDS, CALIFORNIA.** (P/P: M. Rieder, Los Angeles. No. 592. Undivided back.)

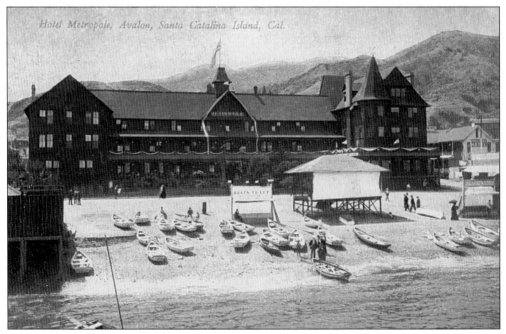

**HOTEL METROPOLE, AVALON, SANTA CATALINA ISLAND, CALIFORNIA.** (P/P: Rosin and Co., NY. No. 856. Made in Germany. Postmark: August 1909.)

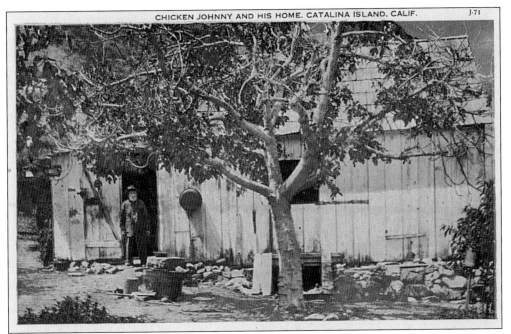

**CHICKEN JOHNNY AND HIS HOME, CATALINA ISLAND, CALIFORNIA.** Chicken John Brinkley arrived in Avalon in 1887. (P/P: Pacific Novelty Co., San Francisco & Los Angeles. No. J71.)

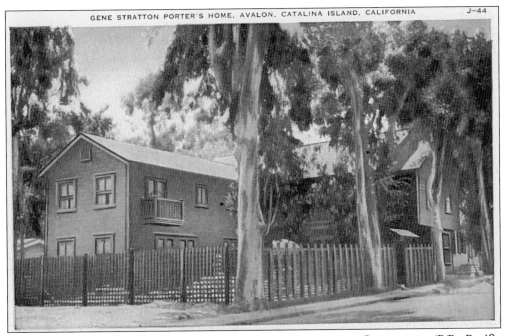

**GENE STRATTON PORTER'S HOME, AVALON, CATALINA ISLAND, CALIFORNIA.** (P/P: Pacific Novelty Co., San Francisco and Los Angeles. No. J44.)

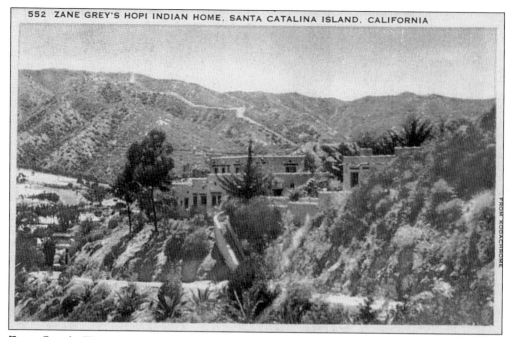

**ZANE GREY'S HOPI INDIAN HOME, SANTA CATALINA ISLAND, CALIFORNIA.** Text on the card reads, "For many years the late Zane Grey, one our leading authors, spent time writing at Catalina Island. His home, built after the style of the Hopi Indian, is still used by the family." (P/P: Longshaw Card Co., Los Angeles. No. 552.)

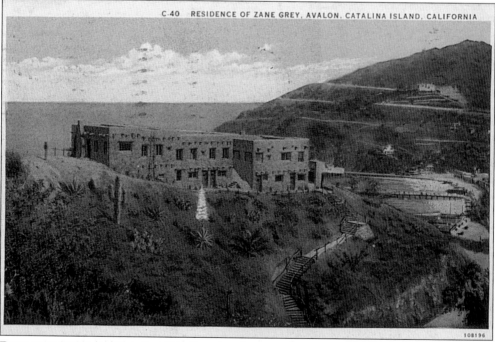

**RESIDENCE OF ZANE GREY, AVALON, CATALINA ISLAND, CALIFORNIA.** (P/P: Western Publishing and Novelty Co., Los Angeles. No. C40. Postmark: June 1932.)

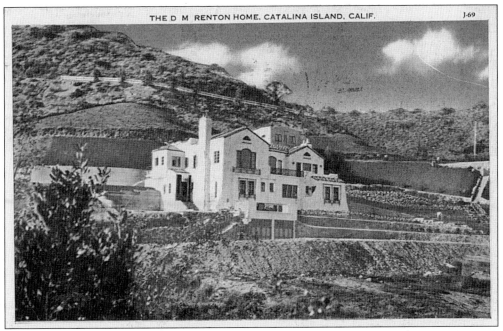

THE D.M. RENTON HOME, CATALINA ISLAND, CALIFORNIA. (P/P: Pacific Novelty Co., San Francisco and Los Angeles. No. J69. Postmark: May 1930.)

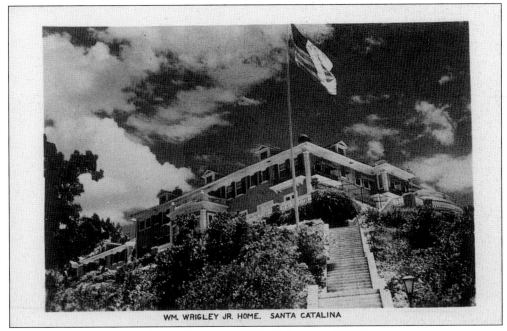

WM. WRIGLEY JR. HOME, SANTA CATALINA. (P/P: Unknown. EKE.)

51

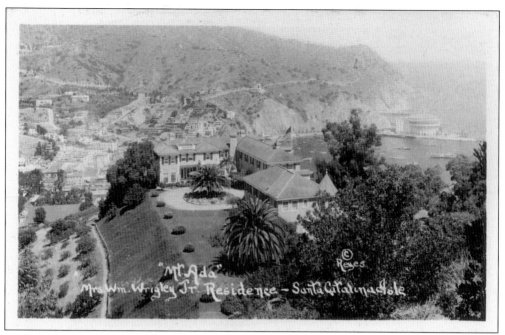

**"Mt. Ada" Mrs. Wm. Wrigley Jr. Residence, Santa Catalina Island.** (P/P: Copyright Reyes.)

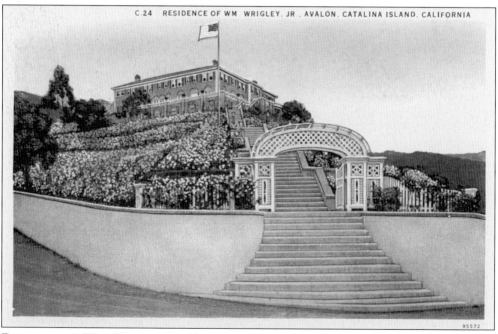

**Residence of Wm. Wrigley Jr., Avalon, Catalina Island, California.** (P/P: Western Publishing and Novelty Co., Los Angeles. No. C24.)

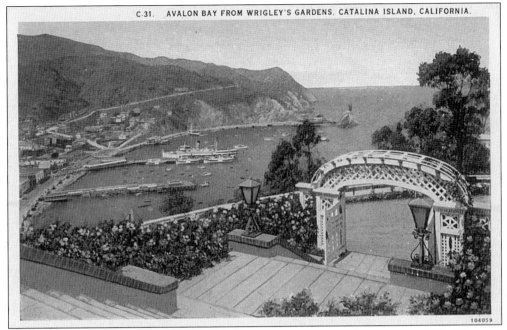

AVALON BAY FROM WRIGLEY'S GARDENS, CATALINA ISLAND, CALIFORNIA. (P/P: Western Publishing and Novelty Co., Los Angeles. No. C31.)

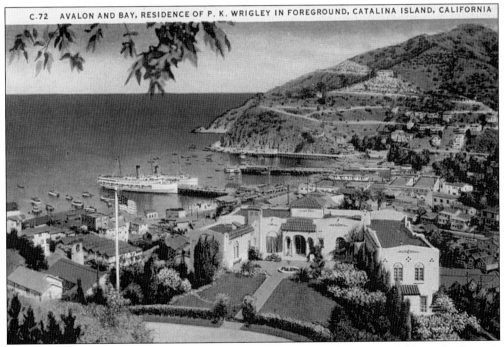

AVALON AND BAY, RESIDENCE OF P.K. WRIGLEY IN FOREGROUND, CATALINA ISLAND, CALIFORNIA. (P/P: Western Publishing and Novelty Co., C72.)

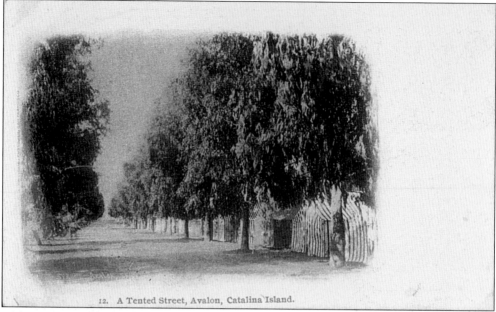

12. A Tented Street, Avalon, Catalina Island.

**A TENTED STREET, AVALON, CATALINA ISLAND.** (P/P: Edward H. Mitchell, San Francisco. No. 12. Private Mailing Card. Undivided back.)

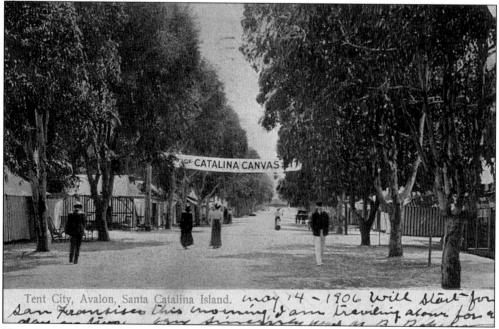

Tent City, Avalon, Santa Catalina Island.

**TENT CITY, AVALON, SANTA CATALINA ISLAND.** (P/P: M. Rieder, Los Angeles and Leipzig. No. 3131. Undivided back. Postmark: May 1906.)

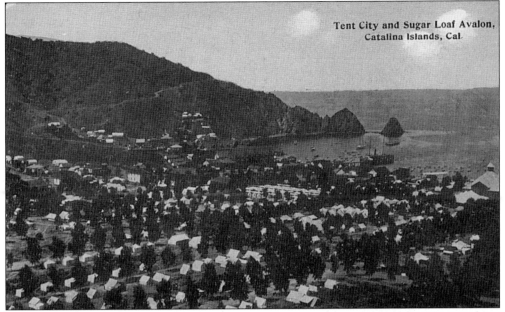

**Tent City and Sugar Loaf, Avalon, Catalina Islands, California.** (P/P: Western Publishing and Novelty Co., Los Angeles. No. 349.)

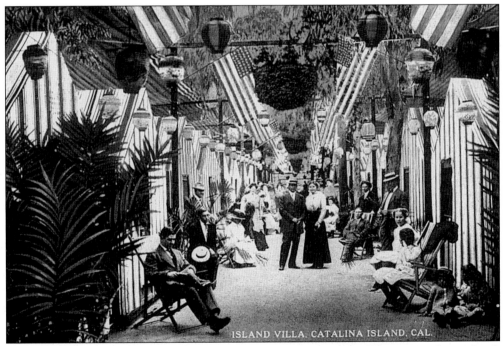

**Island Villa, Catalina Island, California.** (P/P: Catalina Novelty Co., Catalina Island, CA. No. A69672.)

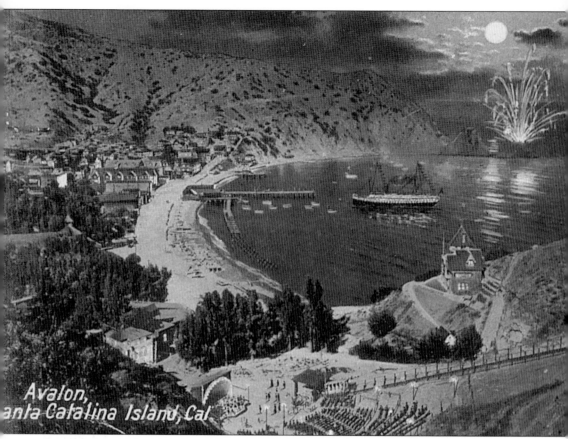

Avalon,
anta Catalina Island, Cal

AVALON, SANTA CATALINA ISLAND, CALIFORNIA. (P/P: Newman Post Card Co., No. E15. Postmark: June 1910.)

# *Three*
# THE CASINO AT CATALINA

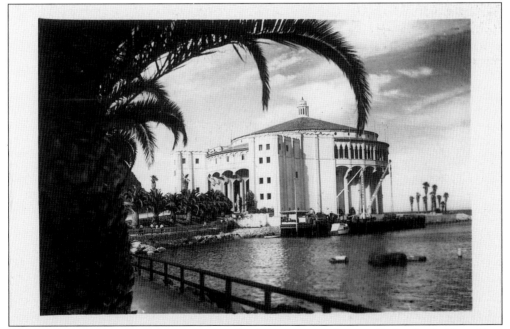

**THE CASINO AT CATALINA.** The casino was built in 1928, and was 140-feet high (the tallest building in Los Angeles County at that time) and 178 feet in diameter. (P/P: Unknown. ECK.)

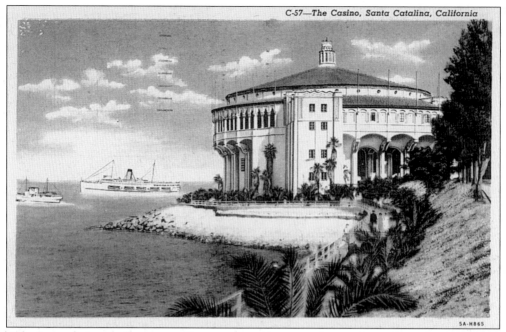

C-57—The Casino, Santa Catalina, California

THE CASINO, SANTA CATALINA, CALIFORNIA. Text on the card reads, "The gorgeous Catalina Island Casino is a two million dollar 'Palace of Pleasure' located midway between Hotel St. Catherine and the town of Avalon. It is the only building of its size in the world, erected on a full circular plan. A mammoth motion picture theatre is on the ground floor and above the world's largest circular ballroom." (P/P: Western Publishing and Novelty Co., Los Angeles. No. C57. Postmark: August 1947.)

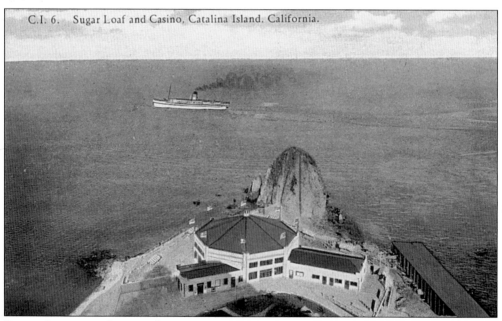

C.I. 6. Sugar Loaf and Casino, Catalina Island, California.

SUGAR LOAF AND CASINO, CATALINA ISLAND, CALIFORNIA. (P/P: Western Publishing and Novelty Co., Los Angeles. No. CI6.)

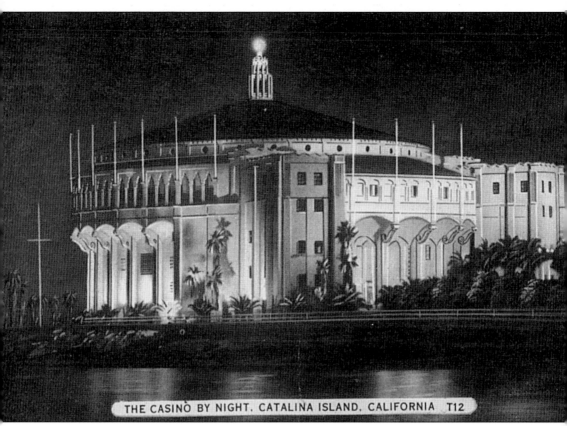

THE CASINO BY NIGHT, CATALINA ISLAND, CALIFORNIA T12

**THE CASINO BY NIGHT, CATALINA ISLAND, CALIFORNIA.** The ballroom dance floor had its grand opening on May 29, 1929. (P/P: Tichnor Art Co., No. T12.)

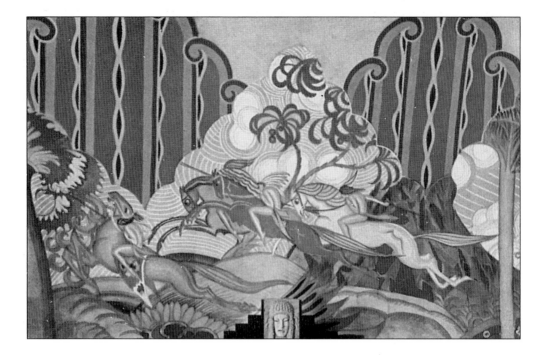

CATALINA CASINO MURALS. Text on the cards reads, "Mural decorations in Casino Theatre, a gorgeous feature of this two-million dollar pleasure palace. Indirect lighting with 800 globes playing different colored light in succession upon the murals produces an exquisite effect. The Catalina Casino has no pillars or partitions in the theatre or ballroom." (P/P: Unknown.)

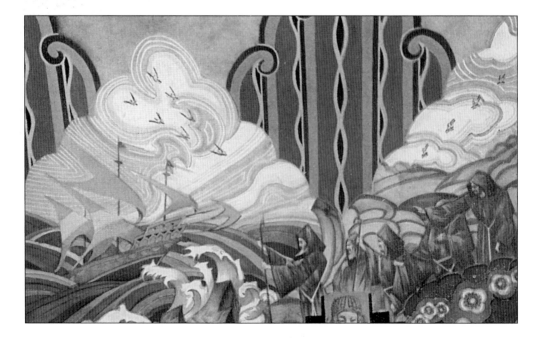

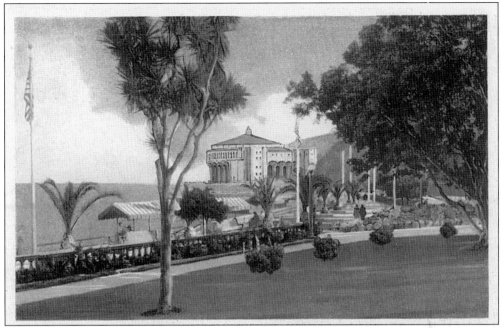

The Casino as Seen from Hotel St. Catherine, Catalina. (P/P: Unknown.)

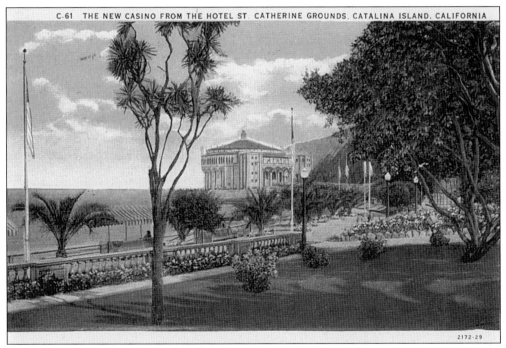

The New Casino from the Hotel St. Catherine Grounds, Catalina Island, California. Text on the card reads, "This beautiful island lies 22 miles off the coast of California. It was purchased almost 30 years ago by W.R. Wrigley Jr. for 3.5 million dollars and is now the vacation center of the Southwest." (P/P: Western Publishing and Novelty Co., Los Angeles. No. C61. Postmark: August 1932.)

61

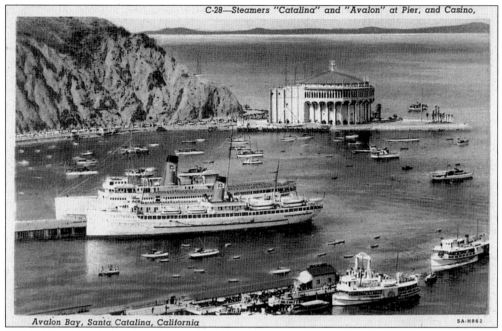

Avalon Bay, Santa Catalina, California

SA-H862

**STEAMERS *CATALINA* AND *AVALON* AT PIER, AND CASINO, AVALON BAY, SANTA CATALINA ISLAND, CALIFORNIA.** Text on the card says, "Two large ocean steamships, the *Catalina* and the *Avalon* are built to safely and comfortably accommodate thousands of passengers daily on the delightful two hour ocean voyage from the mainland to Santa Catalina." (P/P: Western Publishing and Novelty Co., Los Angeles. No. C28.)

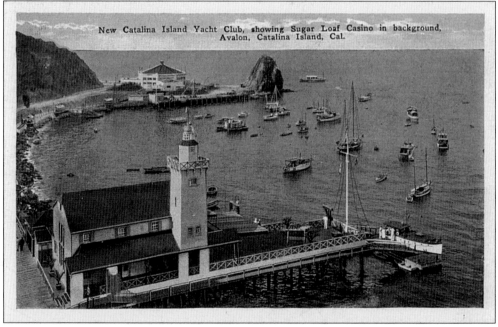

New Catalina Island Yacht Club, showing Sugar Loaf Casino in background, Avalon, Catalina Island, Cal.

**NEW CATALINA ISLAND YACHT CLUB, SHOWING SUGAR LOAF CASINO IN BACKGROUND, AVALON, CATALINA ISLAND, CALIFORNIA.** (P/P: E.C. Kropp, Milwaukee. No. 30974N.)

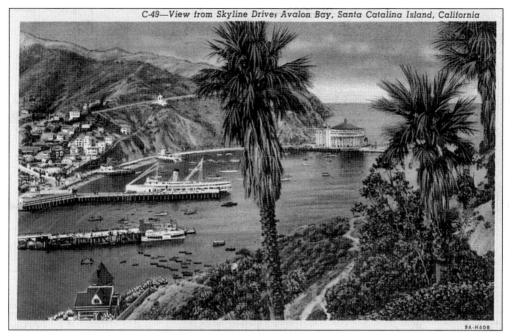

VIEW FROM SKYLINE DRIVE, AVALON BAY, SANTA CATALINA ISLAND, CALIFORNIA. Text on the card reads, "The view from Skyline Drive is an impressive one. Nowhere is a spot more radiantly beautiful than this colorful harbor." (P/P: Western Publishing and Novelty Co., Los Angeles. No. C49. Postmark: August 1946.)

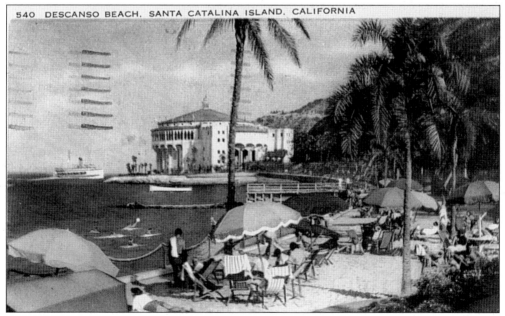

DESCANSO BEACH, SANTA CATALINA ISLAND, CALIFORNIA. Text on the card reads, "Beautiful Descanso Beach in front of the Hotel St. Catherine, with its semi-tropical gardens is one of the most colorful spots on the Island." (P/P: Longshaw Card Co., Los Angeles. No. 540. Postmark: August 1946.)

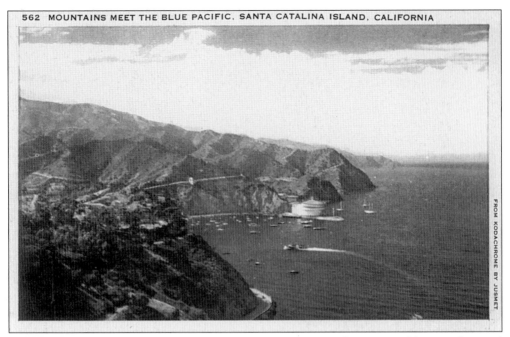

**MOUNTAINS MEET THE BLUE PACIFIC, SANTA CATALINA ISLAND, CALIFORNIA.** Text on the card reads, "Santa Catalina Island (volcanic origin) is believed to have been once part of the mainland, and at various times has been submerged and elevated similar to the whole coast of California. The average height of the Island is 1,500 feet, except at the Isthmus which is only 20 feet above sea level." (P/P: Longshaw Card Co., Los Angeles. No. 562.)

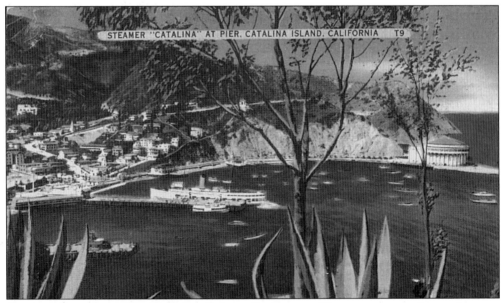

**STEAMER *CATALINA* AT PIER, CATALINA ISLAND, CALIFORNIA.** The message on the card states, "This is where Aunt Julia and I spent the day yesterday. There are lovely palm trees and banana trees with big bunches of green bananas on them and the water is very blue." (P/P: Tichnor Art Co., Los Angeles. No. T9. Postmark August 1938.)

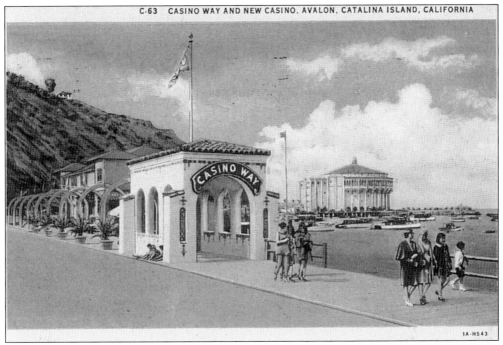

**Casino Way and New Casino, Avalon, Catalina Island, California.** (P/P: Western Publishing and Novelty Co., Los Angeles. No. C63. Postmark: December 1933.)

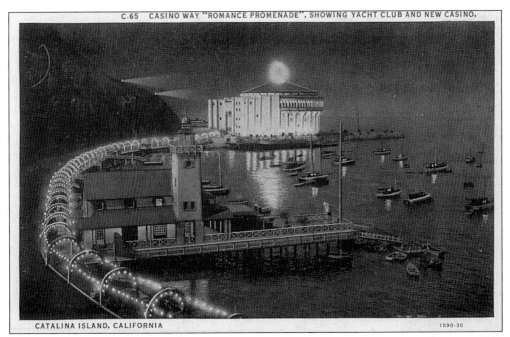

**Casino Way "Romance Promenade," Showing Yacht Club and New Casino.** (P/P: Western Publishing and Novelty Co., Los Angeles. No. C65.)

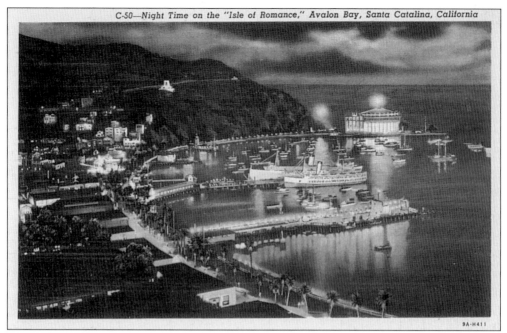

NIGHTTIME ON THE "ISLE OF ROMANCE" AVALON BAY, SANTA CATALINA, CALIFORNIA. Text on the card reads, "Avalon Bay, a thrilling scene of bustling activity by day, a 'Fairyland by Night.' Like a jewel in an exquisite setting, the view of Avalon at right from the hills above is a never to be forgotten sight." (P/P: Western Publishing and Novelty Co., Los Angeles. No. C50.)

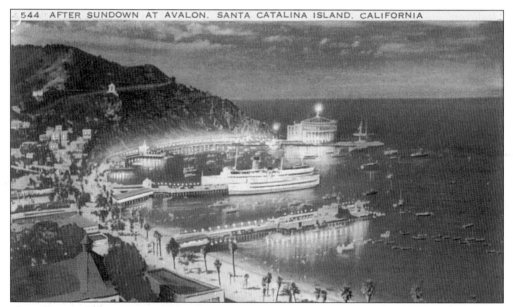

AFTER SUNDOWN AT AVALON, SANTA CATALINA ISLAND, CALIFORNIA. Text on the card reads, "At night myriad lights reflecting on the bay, music across the water, rustling palm trees, and the murmur of the waves on the white sands makes Avalon one of the most romantic spots of the world." (P/P: Longshaw Card Co., Los Angeles. No. 544.)

## *Four*
# BOATS, FISH, AND BIRDS

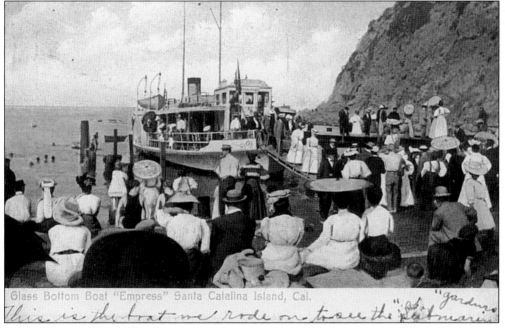

Glass Bottom Boat "Empress" Santa Catalina Island, Cal.

*This is the boat we rode on to see the "submarine gardens."*

**GLASS BOTTOM BOAT** *EMPRESS* **SANTA CATALINA ISLAND, CALIFORNIA.** (P/P: Newman Post Card Co., Los Angeles. No. E8. Made in Germany.)

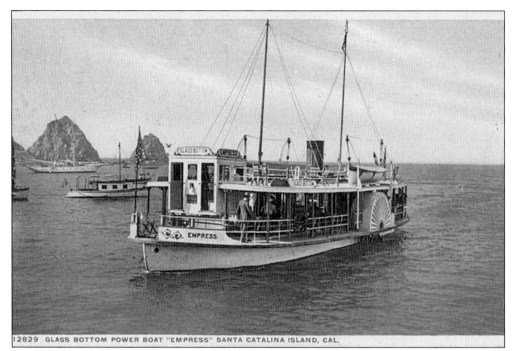

12829 GLASS BOTTOM POWER BOAT "EMPRESS" SANTA CATALINA ISLAND, CAL.

GLASS BOTTOM POWER BOAT *EMPRESS* SANTA CATALINA ISLAND, CALIFORNIA. (P/P: Detroit Publishing Co. No. 12829.)

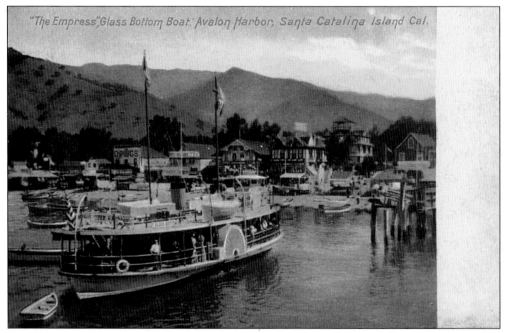

"The Empress" Glass Bottom Boat, Avalon Harbor, Santa Catalina Island Cal.

THE *EMPRESS*, GLASS BOTTOM BOAT, AVALON HARBOR, SANTA CATALINA ISLAND, CALIFORNIA. (P/P: Newman Post Card Co., Los Angeles. No. 4535.)

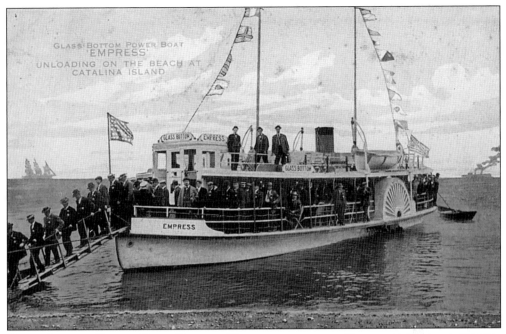

**GLASS BOTTOM POWER BOAT *EMPRESS* UNLOADING ON THE BEACH AT CATALINA ISLAND.** Compliments of the Meteor Boat Co. (P/P: Van Ornum Colorprint Co., Los Angeles. No. 15.)

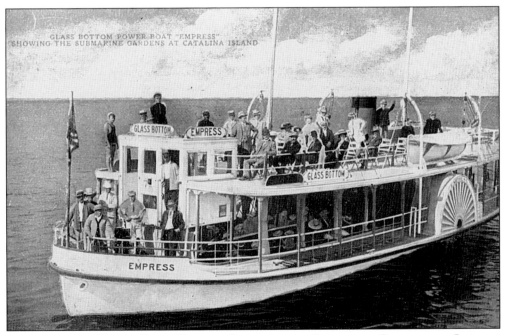

**GLASS BOTTOM POWER BOAT *EMPRESS* SHOWING THE SUBMARINE GARDENS AT CATALINA ISLAND.** (P/P: Neuner Co., Los Angeles. No. 1679.)

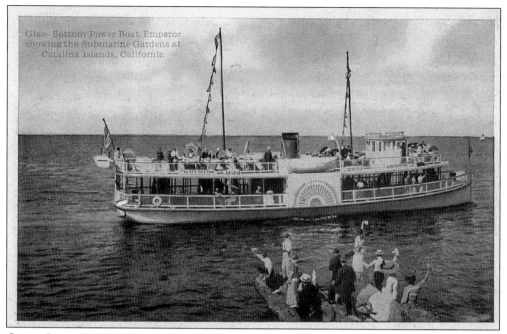

**GLASS BOTTOM POWER BOAT *EMPEROR* SHOWING THE SUBMARINE GARDENS AT CATALINA ISLANDS, CALIFORNIA.** (P/P: George Rice and Sons, Los Angeles.)

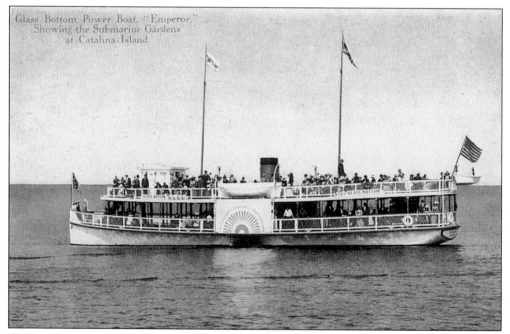

**GLASS BOTTOM POWER BOAT *EMPEROR* SHOWING THE SUBMARINE GARDENS AT CATALINA ISLAND.** (P/P: Meteor Boat Co.)

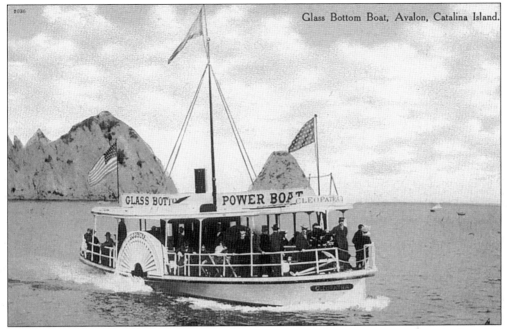

**GLASS BOTTOM BOAT, AVALON, CATALINA ISLAND.** This early picture was taken before the casino was built. (P/P: Benham Co. Los Angeles. No. 2036.)

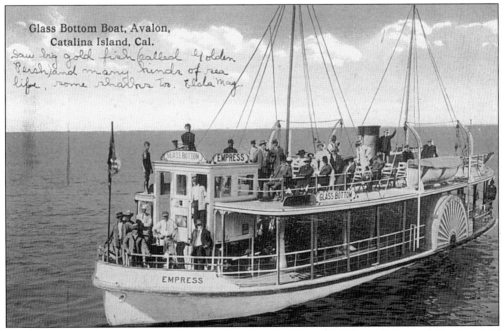

**GLASS BOTTOM BOAT, AVALON, CATALINA ISLAND, CALIFORNIA.** The message on the front of the card reads, "Saw big gold fish (called Perch) and many kinds of sea life, some sharks too. Elda May." (P/P: Catalina Novelty Co., Catalina Island. No. R55093.)

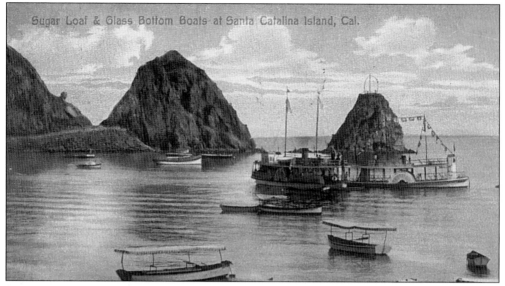

**SUGAR LOAF AND GLASS BOTTOM BOATS AT SANTA CATALINA ISLAND, CALIFORNIA.** Text on the card states, "The great Summer and Winter Resort of California. 2 3/4 hours ride from Los Angeles. Noted for Climate, Marine Gardens, Fishing, Boating, Bathing. First Class Hotels and tent accommodations. (P/P: Newman Post Card Co., Los Angeles. No. E23. Postmark: July 1908.)

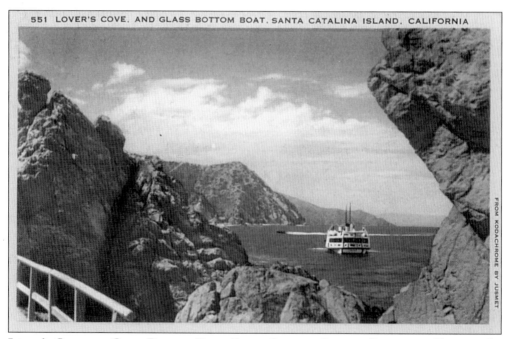

**LOVER'S COVE AND GLASS BOTTOM BOAT, SANTA CATALINA ISLAND, CALIFORNIA.** Text on the card reads, "Along the rocky shoreline, the visitors view the colorful undersea life of Catalina's renowned Submarine Gardens (seventeen miles long), waving kelp, vivid masses of fascinating fish and a diving exhibition three the spectators on this unique trip." (P/P: Longshaw Card Co., Los Angeles. No. 551.)

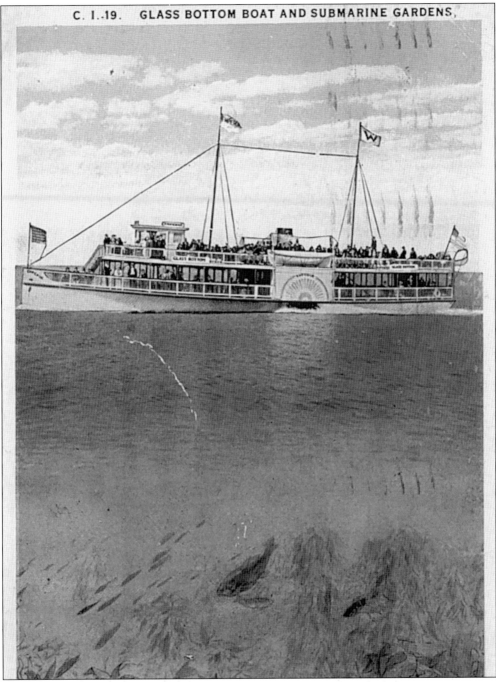

GLASS BOTTOM BOAT AND SUBMARINE GARDENS, CATALINA ISLAND, CALIFORNIA. Text on the card reads, "The Submarine Gardens contain more than thirty varieties of kelp and as many kinds of fish. This strange and wonderful sea life may be viewed to the depths of 75 feet, owing to the remarkably clear waters about Avalon, as the large passenger boats with plate glass bottoms glide slowly over the gardens." (P/P: Western Publishing and Novelty Co., Los Angeles. No. CI19. Postmark: August 1929.)

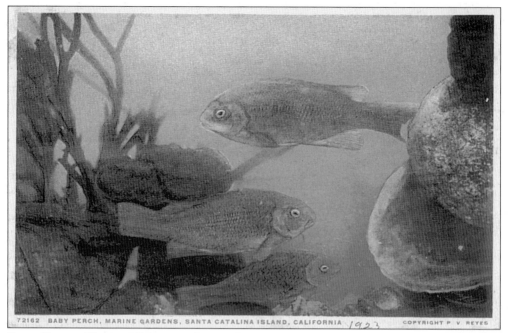

**BABY PERCH, MARINE GARDENS, SANTA CATALINA ISLAND, CALIFORNIA.** (Copyright: P.V. Reyes. Detroit Publishing Co. No. 72162. Postmark: August 1923.)

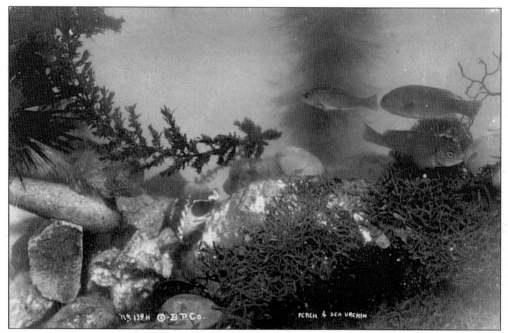

**PERCH AND SEA URCHIN [UNDERWATER GARDENS].** (P/P: Baker Photographic, Avalon, CA. No. 139 H. Artura.)

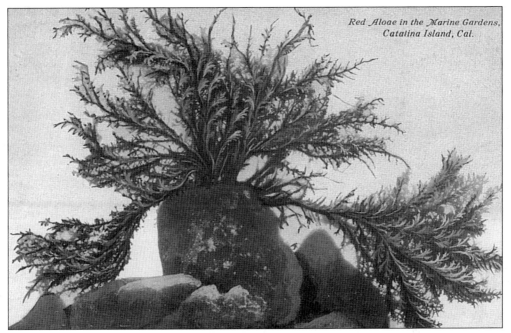

**RED ALOAE IN THE MARINE GARDENS, CATALINA ISLAND, CALIFORNIA.** (P/P: Benham Co., Los Angeles. No. A11811.)

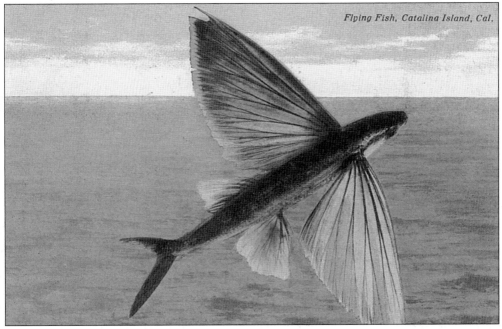

**FLYING FISH, CATALINA ISLAND, CALIFORNIA.** (P/P: Benham Co., Los Angeles. No. 2032. Postmark: July 1911.)

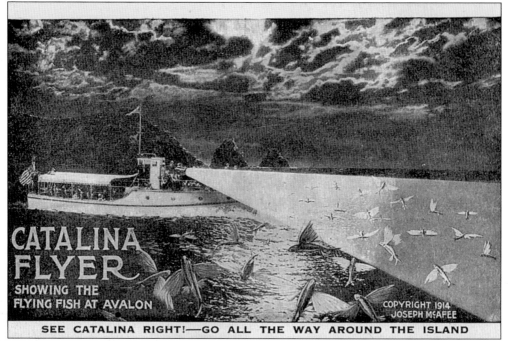

CATALINA FLYER SHOWING THE FLYING FISH AT AVALON. (See Catalina right, and go all the way around the island.) J. McAfee began flying fish boats in 1911. (P/P: Joseph McAfee. Copyright: 1914.)

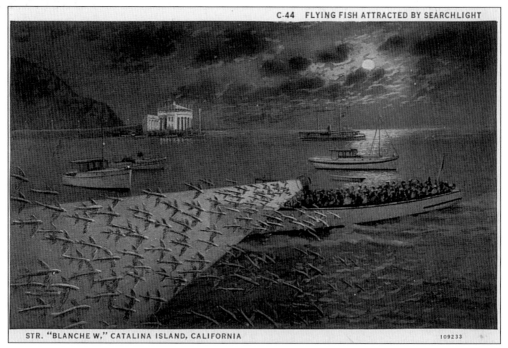

FLYING FISH ATTRACTED BY SEARCHLIGHT. STEAMER *BLANCHE* W. CATALINA ISLAND, CALIFORNIA. (P/P: Western Publishing and Novelty Co., Los Angeles. No. C44.)

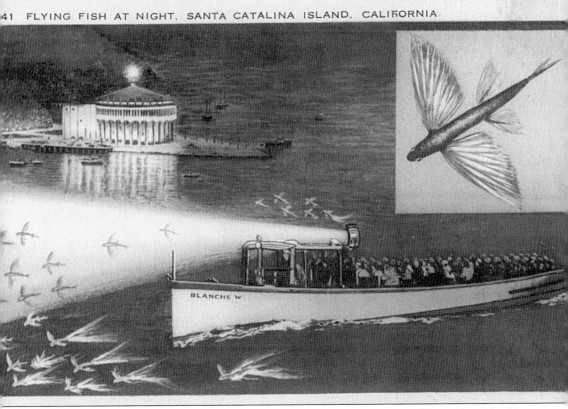

**FLYING FISH AT NIGHT, SANTA CATALINA ISLAND, CALIFORNIA.** Text on the card reads, "In Catalina waters the famous flying fish (12 inches to 22 inches long) fly as much as 40 miles per hour for distances as great as 300 yards, only to drag back into the water when their wings become dry." (P/P: Longshaw Card Co., Los Angeles. No. 541.)

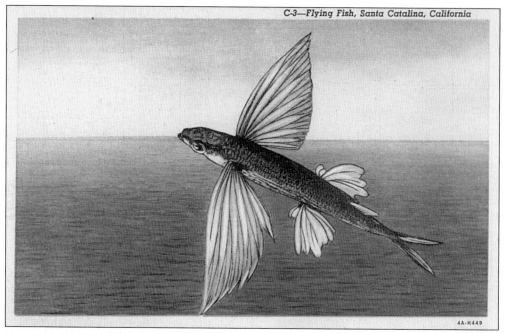

4A-H449

FLYING FISH, SANTA CATALINA, CALIFORNIA. Text on this card reads, "One of the strange sights to the tourist is the Flying Fish, which at certain periods of the year are numerous about the Island. During the summer months, nightly, a trip is made with a boat equipped with powerful searchlights, which when played upon the water attract these fish by the hundreds." (P/P: Western Publishing and Novelty Co., Los Angeles. No. C3.)

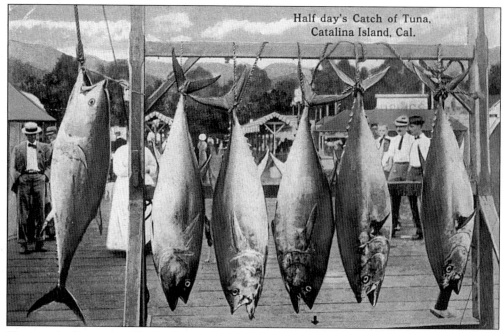

Half day's Catch of Tuna, Catalina Island, Cal.

HALF-DAY'S CATCH OF TUNA, CATALINA ISLAND, CALIFORNIA. (P/P: Catalina Novelty Co., Catalina Island, CA. No. R55097. Postmark: August 1915.)

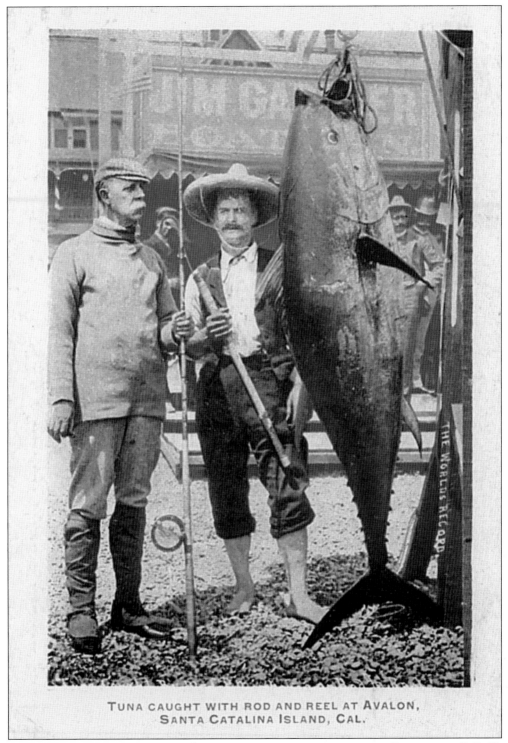

TUNA CAUGHT WITH ROD AND REEL AT AVALON,
SANTA CATALINA ISLAND, CAL.

Caught with Rod and Reel, 384 Pounds, Santa Catalina Island, California. (P/P: M. Rieder, Los Angeles. No. 514. Undivided back. Postmark: September 1907.)

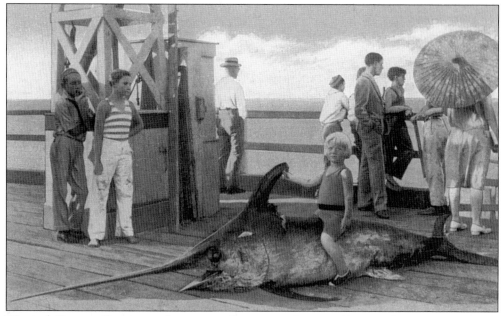

**WORLD'S RECORD BROADBILL SWORDFISH CAUGHT AT CATALINA ISLAND, CALIFORNIA: WEIGHT 571 POUNDS.** (P/P: C.T. Co., Chicago. No. 10279.)

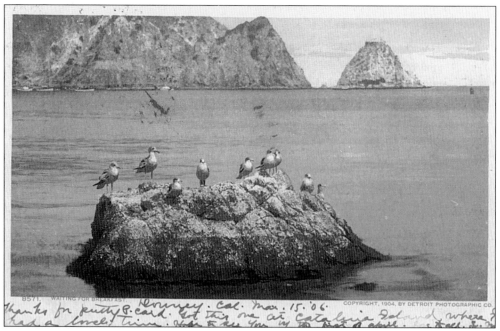

**WAITING FOR BREAKFAST.** (P/P: Detroit Photographic Co. Copyright: 1904. No. 8571. Undivided back. Postmark: March 1906.)

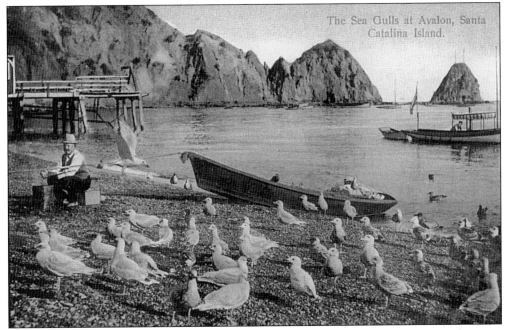

**The Sea Gulls at Avalon, Santa Catalina Island.** (P/P: M. Rieder, Los Angeles. No. 4587. Made in Germany.)

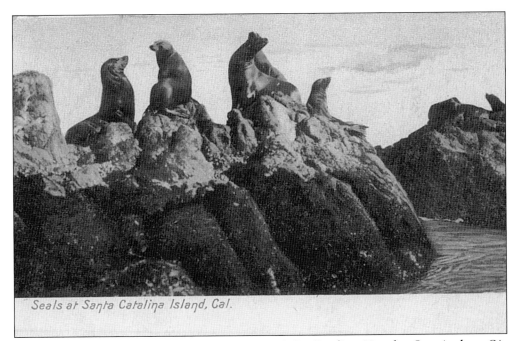

Seals at Santa Catalina Island, Cal.

**Seals at Santa Catalina Island, California.** (P/P: Catalina Novelty Co., Avalon, CA. Made in Germany. Undated.)

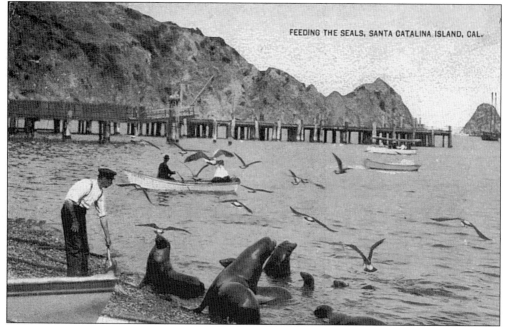

FEEDING THE SEALS, SANTA CATALINA ISLAND, CAL.

**FEEDING THE SEALS, SANTA CATALINA ISLAND, CALIFORNIA.** (P/P: Unknown. Postmark: March 1914.)

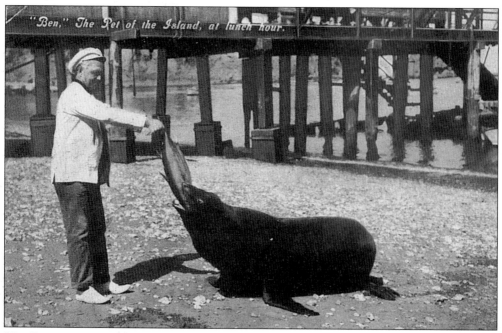

"Ben," The Pet of the Island, at lunch hour.

**"BEN" THE PET OF THE ISLAND, AT LUNCH HOUR.** (P/P: Benham Co., Los Angeles. No. 2830.)

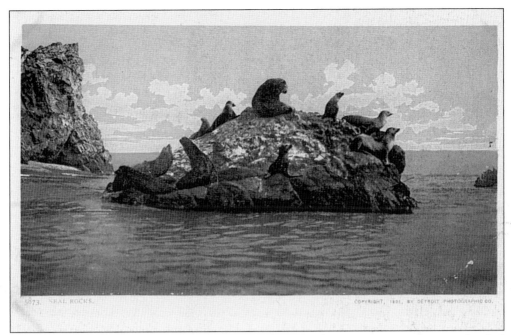

**SEAL ROCKS.** (P/P: Detroit Photographic Co. Copyright: 1901. No. 5873. Undivided back.)

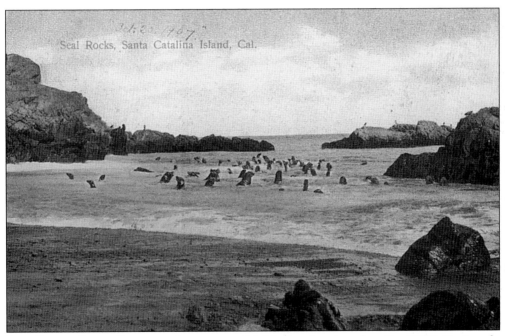

**SEAL ROCKS, SANTA CATALINA, CALIFORNIA.** (M. Rieder, Los Angeles. No. 3822. Postmark: October 1907.)

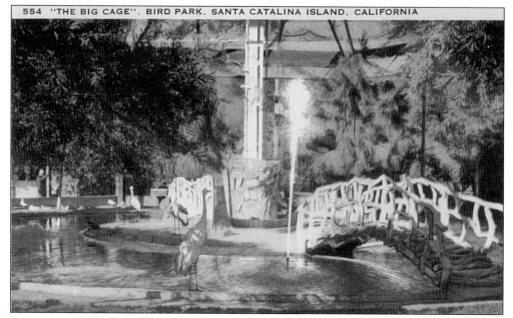

"THE BIG CAGE" BIRD PARK, SANTA CATALINA ISLAND, CALIFORNIA. The Bird Park was opened in 1928. Text on this card reads, "Free for all to enjoy is the Catalina Bird Park (costing $400,000) which has over 6,000 birds of 600 varieties, many of them talking and performing, The 'Big Cage,' which is 80 feet high and 115 feet in diameter was originally an old dance pavilion, and contains over 100 kinds of birds." (P/P: Longshaw Card Co., Los Angeles. No. 554.)

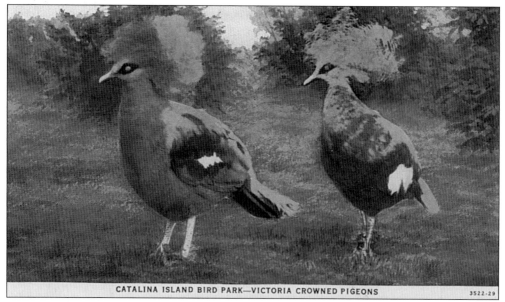

CATALINA ISLAND BIRD PARK—VICTORIA CROWNED PIGEONS

CATALINA ISLAND BIRD PARK—VICTORIA CROWNED PIGEONS. Text on the card reads, "The Catalina Island Bird Park is a 7.5 acre bird sanctuary where specimens of bird life from all over the world may be viewed without admittance charge." (P/P: C.T. American Art Colored, Chicago. No. 3522–29.)

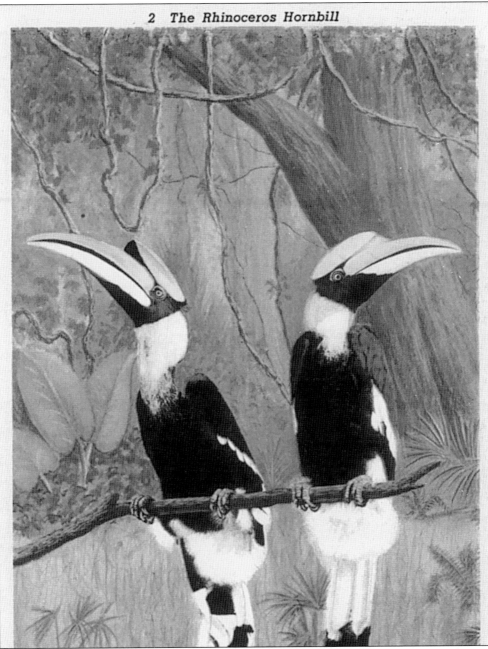

**THE RHINOCEROS HORNBILL, THE BIRD PARK AT SANTA CATALINA ISLAND, CALIFORNIA.** Text on this card states, "THE RHINOCEROS HORNBILL, 'LYNN'S' A native of Malaya and largest of the hornbill family, these birds are very rare and seldom seen even in the wild state. Papa Hornbill seals his mate up in the hollow of a tree during nesting time, feeding her through a small hole big enough for his beak. No chance for Mama Hornbill to neglect her household duties or fly off to Reno for a divorce. The Hornbills feed on fruit and meat and are the most unique and interesting pair of birds in the Santa Catalina Island Bird Park." (P/P: Western Publishing and Novelty Co., Los Angeles. No. 2.)

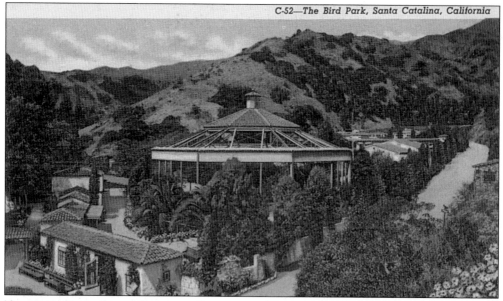

**THE BIRD PARK, SANTA CATALINA, CALIFORNIA.** The text on this card reads, "The Santa Catalina Bird Park comprises about eight acres in a beautiful canyon where thousands of rare species of birds, collected from all over the world, are exhibited free to the public. Here dwell together in a colorful community rare and beautiful birds from every land and clime." (P/P: Western Publishing and Novelty Co., Los Angeles. No. C52.)

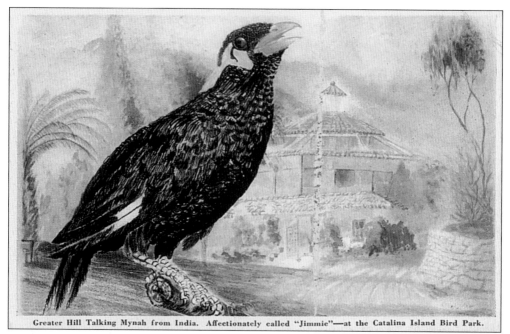

Greater Hill Talking Mynah from India. Affectionately called "Jimmie"—at the Catalina Island Bird Park.

**GREATER HILL TALKING MYNAH BIRD FROM INDIA, AFFECTIONATELY CALLED "JIMMIE" AT THE CATALINA ISLAND BIRD PARK.** Text from this card states, "Jimmie says, 'Hello!' 'How are You!' 'What do you do on Monday?' 'Washie, Washie!' 'Are you going down town?' 'Go catch'em!' 'Pretty Day!' ' Ha, ha, ha, ha!' 'GOODBYE!' 'Watch OUT!'" (P/P: Unknown.)

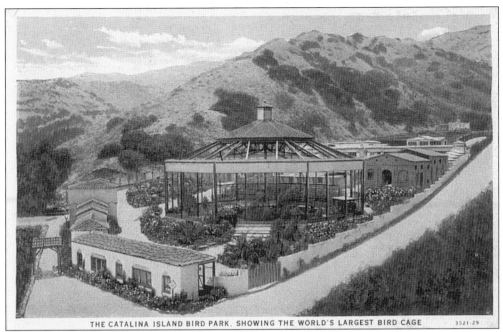

THE CATALINA ISLAND BIRD PARK, SHOWING THE WORLD'S LARGEST BIRD CAGE. (P/P: C.T. American, Chicago. No. 3521–29. Postmark: July 1932.)

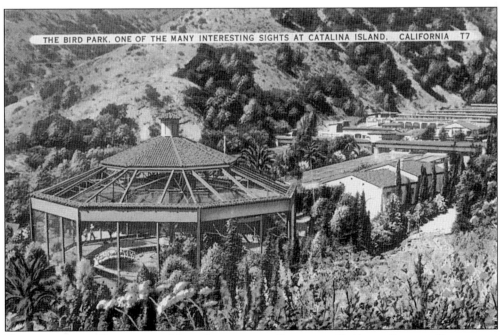

THE BIRD PARK, ONE OF THE MANY INTERESTING SIGHTS AT CATALINA ISLAND, CALIFORNIA. (P/P: Tichnor Art Co., Los Angeles. No. T7.)

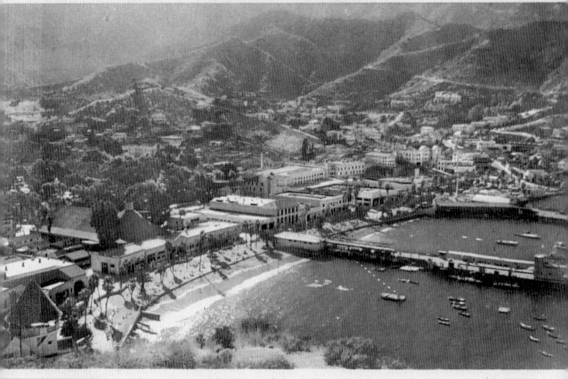

AVALON TOWN, SANTA CATALINA ISLAND, CALIFORNIA. Text on this card reads, "Avalon Town, built on the ruins of an old Indian village, was rebuilt after being destroyed by fire in 1915 and now boasts all modern conveniences. It covers 2.5 sq. miles with a population of about 2,000 permanent residents, which mounts to about 8,000 in the summer season." (P/P: Longshaw Card Co., Los Angeles. No. 557.)

## *Five*
# THE TOWN OF AVALON

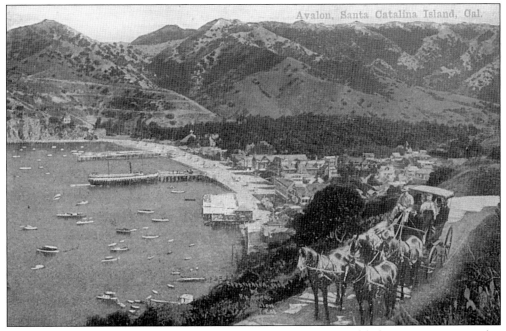

**AVALON, SANTA CATALINA ISLAND, CALIFORNIA.** (P/P: Souvenir Publishing Co., Los Angeles and San Francisco. No. E32.)

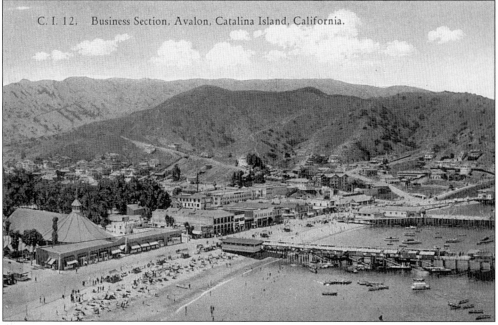

**Business Section, Avalon, Catalina Island, California.** (P/P: Western Publishing and Novelty Co., Los Angeles. No. CI12.)

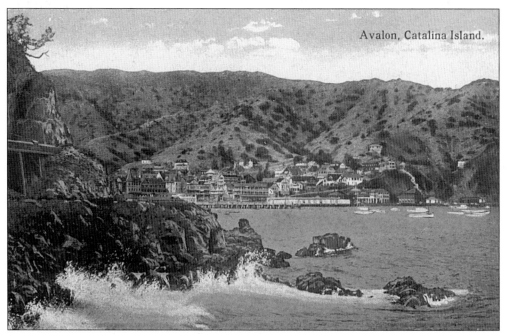

**Avalon, Catalina Island.** (P/P: Catalina Novelty Co., Catalina Island, CA. No. R15317.)

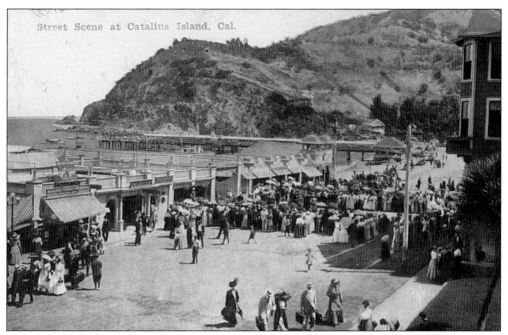

**STREET SCENE AT CATALINA ISLAND, CALIFORNIA.** (P/P: Newman Co., Los Angeles and San Francisco. No. E7. Postmark: July 1912.)

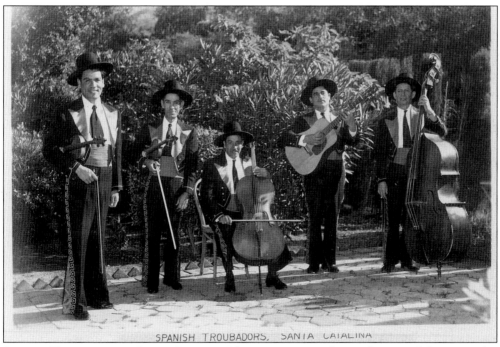

**SPANISH TROUBADOURS, SANTA CATALINA.** The message on the card states, "There are the ones that greet us on arriving at the Island." (P/P: Unknown.)

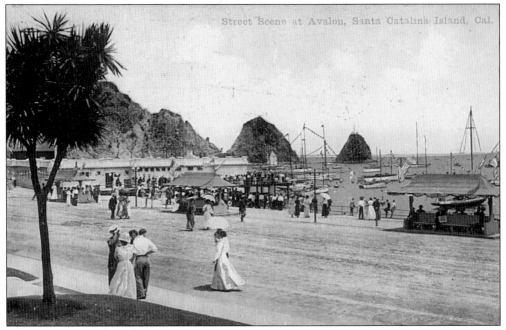

**STREET SCENE AT AVALON, SANTA CATALINA ISLAND, CALIFORNIA.** (P/P: O. Newman Co., Los Angeles and San Francisco. No. 24. Postmark: June 1913.)

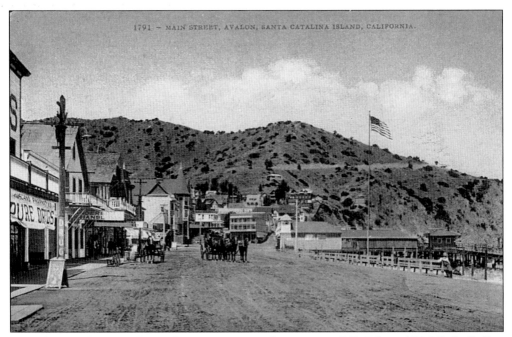

**MAIN STREET, AVALON, SANTA CATALINA ISLAND, CALIFORNIA.** (P/P: Edward H. Mitchell, San Francisco. No. 1791. Postmark: December 1911.)

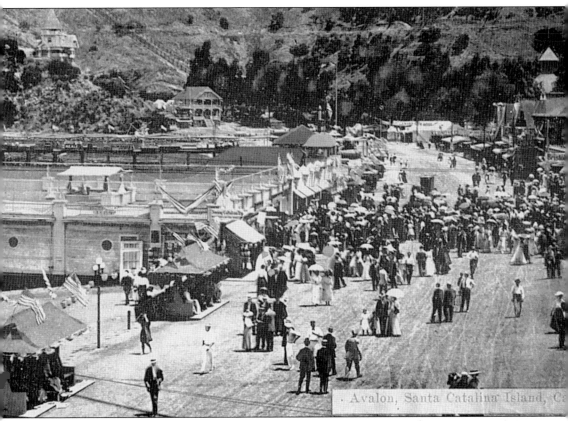

**AVALON, SANTA CATALINA ISLAND, CALIFORNIA.** (P/P: Newman Post Card Co., Los Angles and San Francisco. No. E43.)

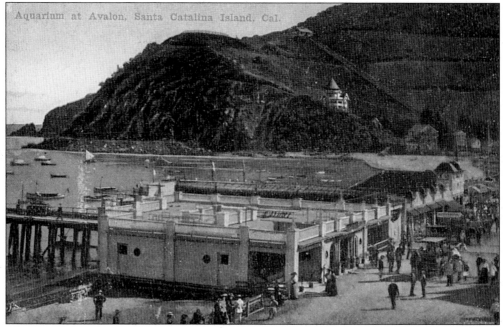

**AQUARIUM AT AVALON, SANTA CATALINA ISLAND, CALIFORNIA.** (P/P: Newman Post Card Co., Los Angeles and San Francisco. No. E20.)

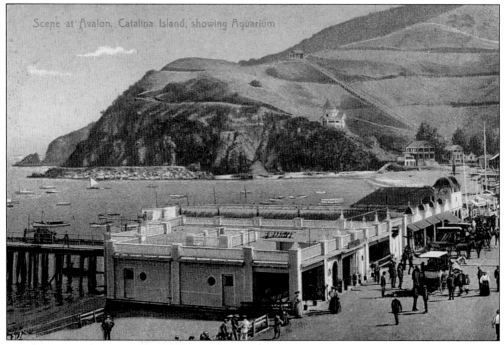

**SCENE AT AVALON, CATALINA ISLAND, SHOWING AQUARIUM.** (P/P: M. Rieder, Los Angeles. No. 9045. Made in Germany.)

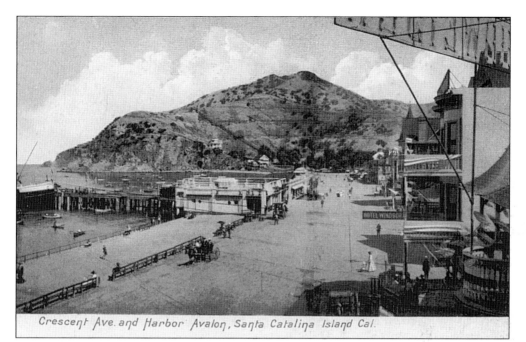

**CRESCENT AVENUE AND HARBOR, AVALON, SANTA CATALINA, CALIFORNIA.** (P/P: Newman Post Card Co., Los Angeles. No. 4534. Made in Germany.)

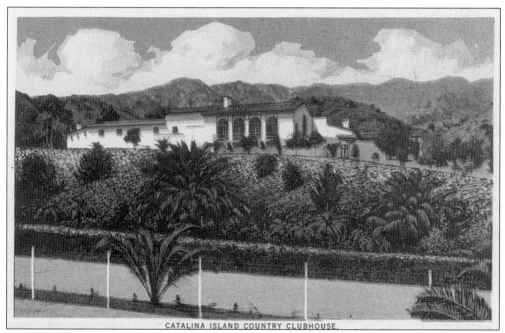

**CATALINA ISLAND COUNTRY CLUBHOUSE.** (P/P: Union Litho. Co., Los Angeles.)

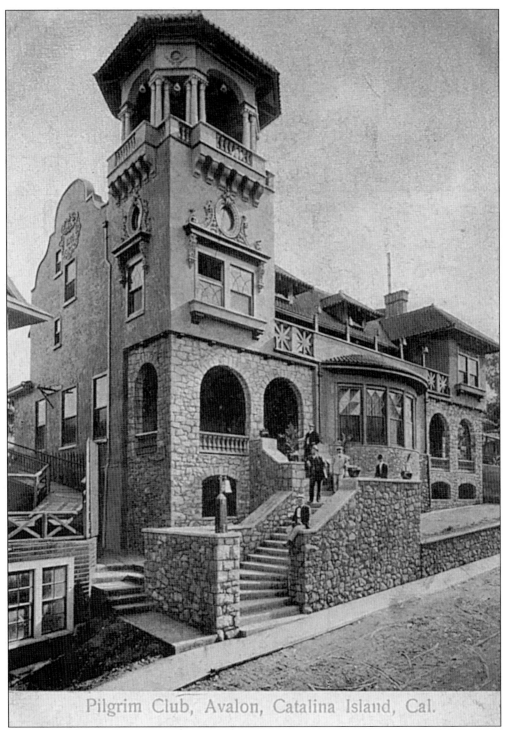

Pilgrim Club, Avalon, Catalina Island, Cal.

**PILGRIM CLUB, AVALON, CATALINA ISLAND, CALIFORNIA.** Erected in 1902 as a gambling club, the Pilgrim Club was destroyed in the 1915 fire. (P/P: M. Rieder, Los Angeles. No. 3273. Undivided back.)

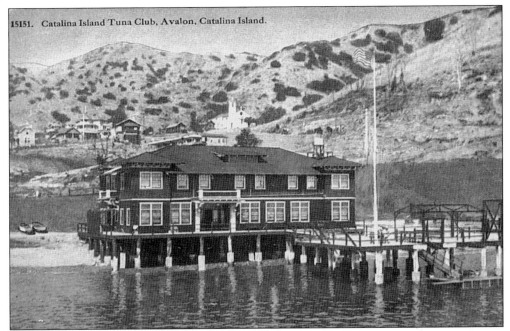

**CATALINA ISLAND TUNA CLUB.** The Tuna Club was founded in 1898. (P/P: H.H.H. No. 15151.)

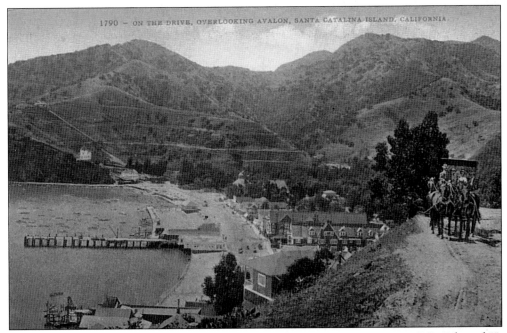

**ON THE DRIVE OVERLOOKING AVALON, SANTA CATALINA ISLAND, CALIFORNIA.** (P/P: Edward H. Mitchell, San Francisco, No. 1790.)

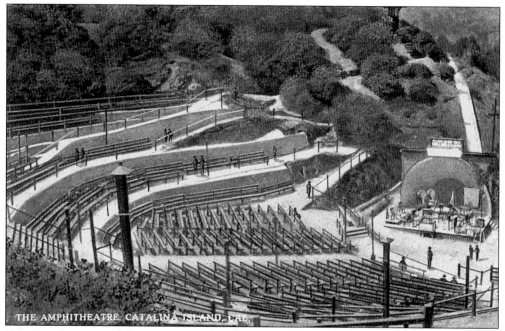

THE AMPHITHEATER, CATALINA ISLAND, CALIFORNIA. The Greek Amphitheater was built in 1904 and torn down in 1931. (P/P: Catalina Novelty Co., Catalina Island, CA. No. A87599.)

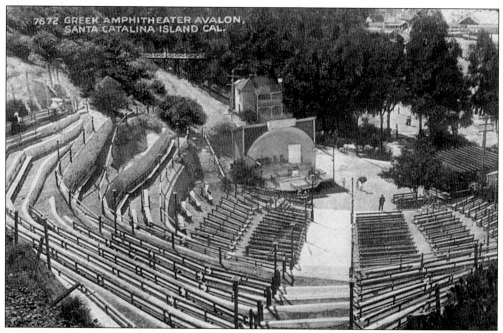

GREEK AMPHITHEATER, AVALON, SANTA CATALINA ISLAND, CALIFORNIA. (P/P: Unknown. No. 7672.)

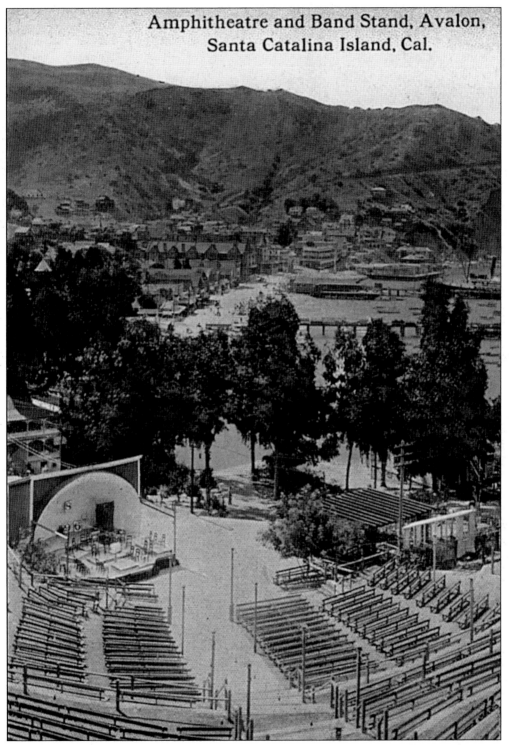

Amphitheatre and Band Stand, Avalon, Santa Catalina Island, Cal.

AMPHITHEATER AND BAND STAND, SANTA CATALINA ISLAND, CALIFORNIA. (P/P: Carlin Post Card Co., Los Angeles. No. 1013.)

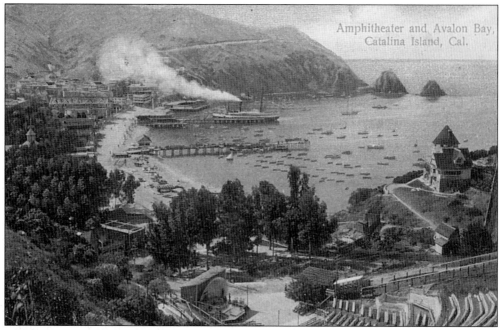

**AMPHITHEATER AND AVALON BAY, CATALINA ISLAND, CALIFORNIA.** The following message was sent from Avalon to a friend in Three Rivers, Michigan: "Don't you wish you were here? I do." (P/P: M. Rieder, Los Angeles. No. 5415. Made in Germany. Postmark:: August 1910.)

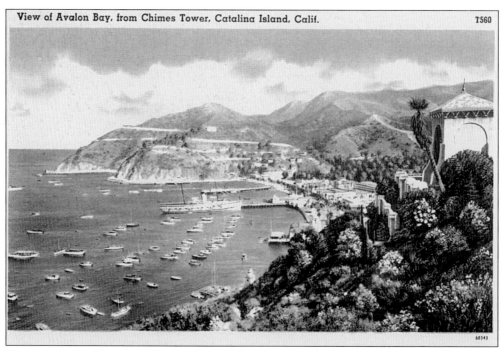

**VIEW OF AVALON BAY FROM CHIMES TOWER, CATALINA ISLAND, CALIFORNIA.** (P/P: Tichnor Art. Co., Los Angeles. No. T560.)

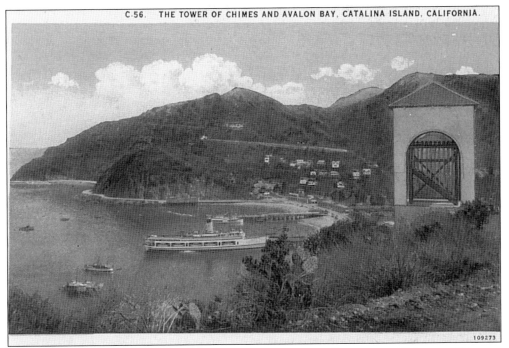

THE TOWER OF CHIMES AND AVALON BAY, CATALINA ISLAND, CALIFORNIA. This set of Deagan Chimes was a gift of the Wrigleys in 1925. (P/P: Western Publishing and Novelty Co., Los Angeles. No. C56.)

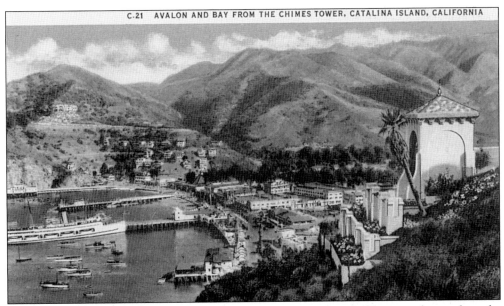

AVALON BAY FROM CHIMES TOWER, CATALINA ISLAND, CALIFORNIA. Text on the card reads, "On the hillside between the St. Catherine Hotel and the town of Avalon, is a Spanish tower containing the Catalina Cathedral Chimes, which ring every quarter hour and are also played announcing the arrival and departure of the steamers." (P/P: Western Publishing and Novelty Co., Los Angeles. No. C21.)

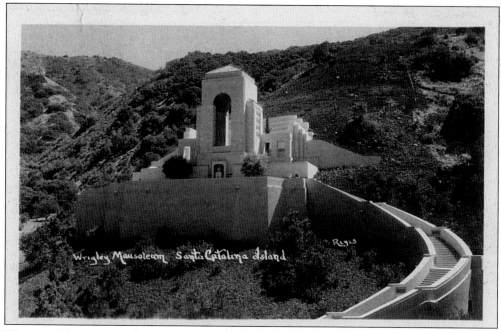

**WRIGLEY MAUSOLEUM, SANTA CATALINA ISLAND.** This was the mausoleum for William Wrigley Jr. until his remains were removed. (P/P: Reyes. Postmark: August 1938.)

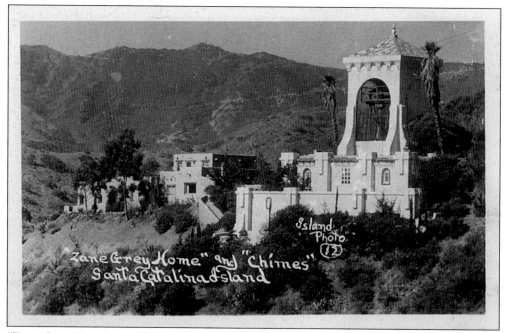

**"ZANE GREY HOME" AND "CHIMES," SANTA CATALINA ISLAND.** (P/P: Island Photo. No. 12, EKE.)

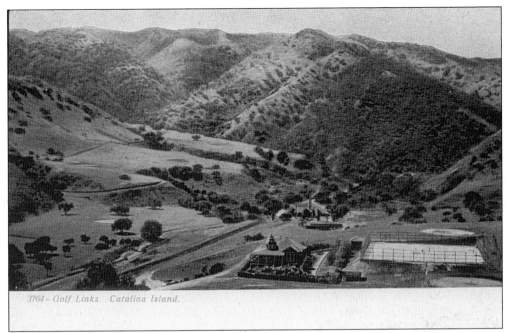

**GOLF LINKS, CATALINA ISLAND.** (P/P: Adolph Selige Publishing Co., St. Louis; Leipzig, Berlin. No. 3764. Undivided back.)

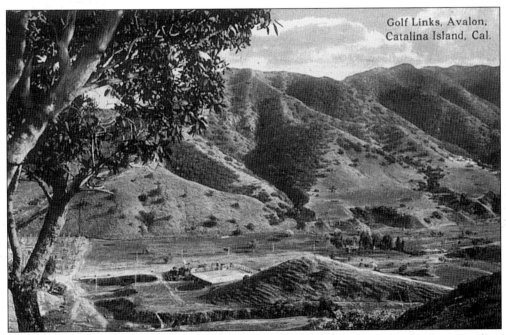

**GOLF LINKS, AVALON, CATALINA ISLAND, CALIFORNIA.** (P/P: Catalina Novelty Co., Catalina Island, CA. No. R55109. Postmark: July 1915.)

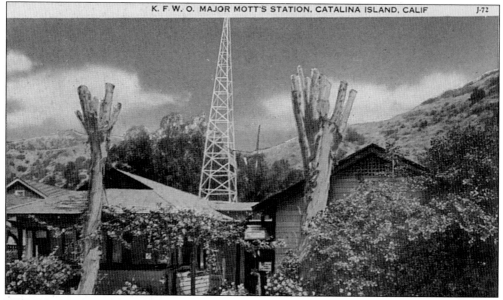

**K.F.W.O. MAJOR MOTT'S STATION, CATALINA ISLAND, CALIFORNIA.** (P/P: Pacific Novelty, San Francisco and Los Angeles. No. J72.)

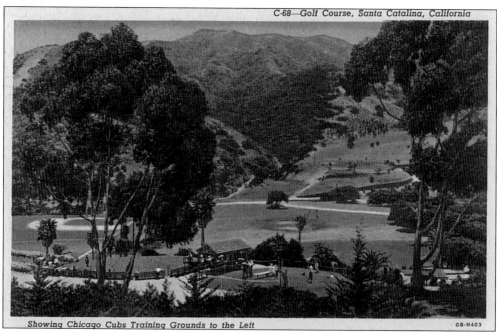

C-68—Golf Course, Santa Catalina, California

Showing Chicago Cubs Training Grounds to the Left

**GOLF COURSE, SANTA CATALINA, CALIFORNIA, SHOWING CHICAGO CUBS' TRAINING GROUNDS TO THE LEFT.** Text on this card reads, "Sporty and spectacular is golf on the course of the Visitor's Country Club. It follows the contours of the hills and canyons, each hole unfolding new views of mountains and ocean. Adjoining the golf course is the Spring training grounds of the Chicago Cubs baseball club." The Cubs held their training camps here from 1921–1951, except for during the war years. (P/P: Western Publishing and Novelty Co., Los Angeles. No. 68.)

104

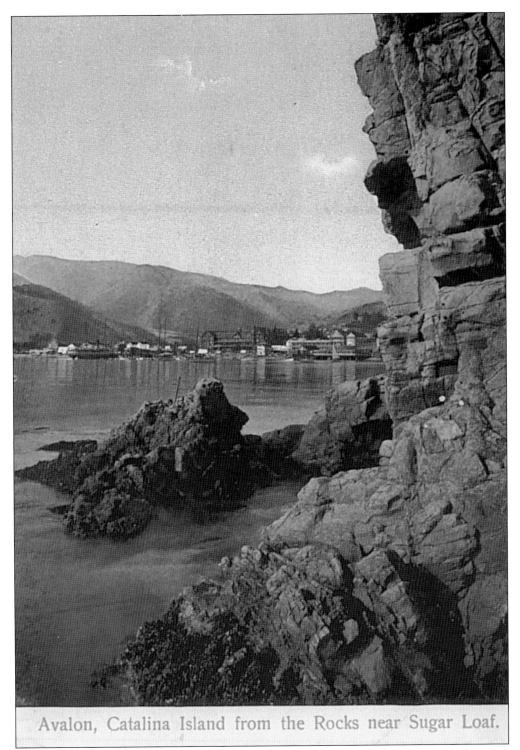

Avalon, Catalina Island from the Rocks near Sugar Loaf.

AVALON, CATALINA ISLAND, FROM THE ROCKS NEAR SUGAR LOAF. (P/P: M. Rieder, Los Angeles. No. 4761. Made in Germany. Postmark: August 7.)

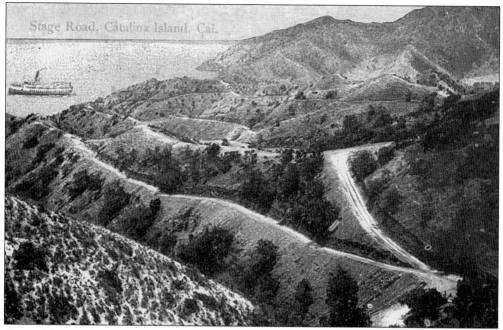

**STAGE ROAD, CATALINA ISLAND, CALIFORNIA.** (P/P: M. Rieder, Los Angeles. No. 45. Postmark: September 1917.)

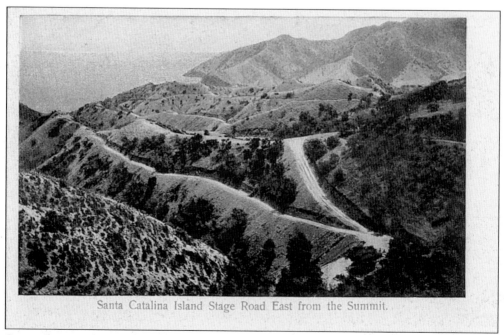

**SANTA CATALINA ISLAND STAGE ROAD EAST FROM THE SUMMIT.** (P/P: M. Rieder, Los Angeles. No. 3250. Made in Germany.)

## *Six*

# OTHER AREAS OF THE ISLAND

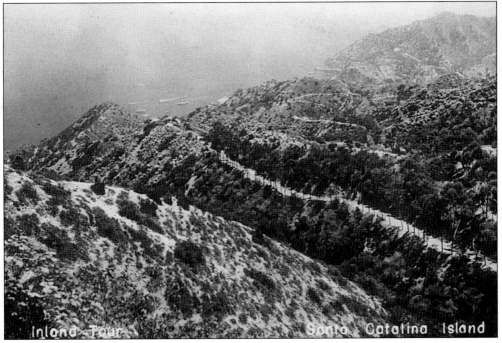

**INLAND TOURS, SANTA CATALINA ISLAND.** (P/P: Angeleno Photo Service, Los Angeles. Postmark: October 1956.)

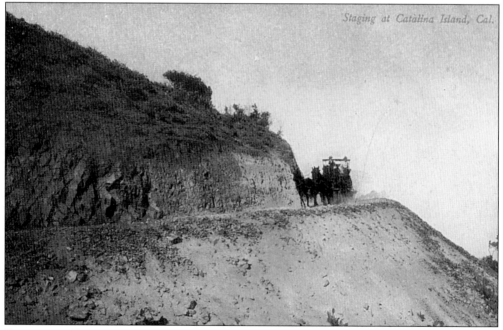

THE STAGE ROAD, SANTA CATALINA ISLAND, CAL. *May 13/05*

*This has been one of best days — my first ride out on the Pacific Ocean & have seen wonderful sights. Glad through bottom boats &c &c all very well Mabby.* H.G.

**THE STAGE ROAD, SANTA CATALINA ISLAND, CALIFORNIA.** (P/P: Detroit Photographic Co. No. 5125. Undivided back. Private Mailing Card. Postmark: May 1905.)

Staging at Catalina Island, Cal.

**STAGING AT CATALINA ISLAND, CALIFORNIA.** (P/P: Rosin and Co., Philadelphia and NY. No. 858. Made in Germany.)

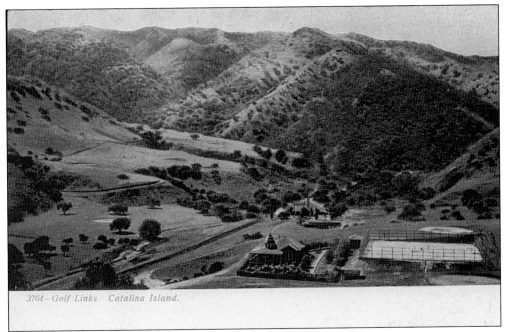

3764—Golf Links  Catalina Island.

**ROUNDING THE LOOP ON THE STAGE ROAD, CATALINA ISLAND, CALIFORNIA.** (P/P: Benham Co., Los Angeles. No. 2888.)

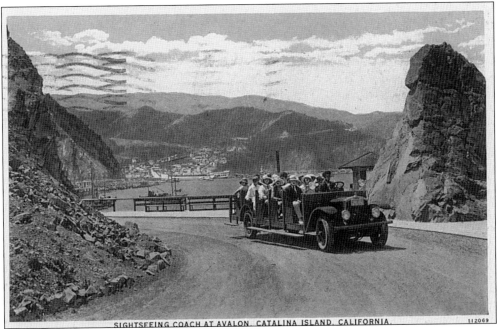

SIGHTSEEING COACH AT AVALON. CATALINA ISLAND. CALIFORNIA.

**SIGHTSEEING COACH AT AVALON, CATALINA ISLAND, CALIFORNIA.** (P/P: C.T., Chicago. No. 112069. Postmark: August 1927.)

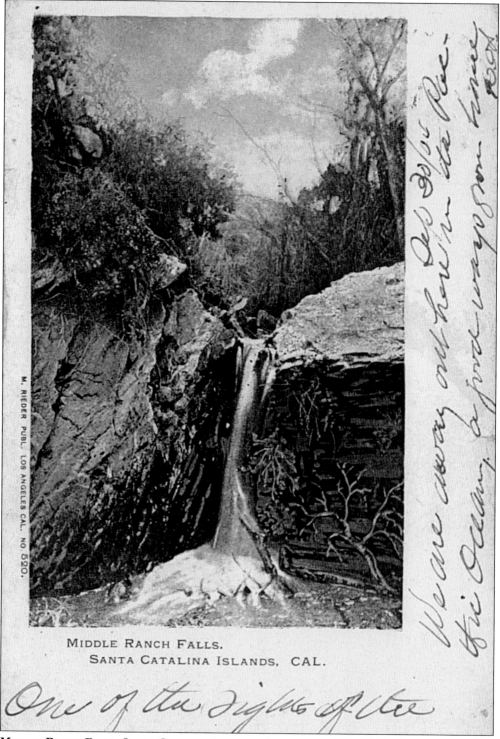

MIDDLE RANCH FALLS.
SANTA CATALINA ISLANDS, CAL.

**MIDDLE RANCH FALLS, SANTA CATALINA ISLANDS, CALIFORNIA.** (P/P: M. Rieder, Los Angeles. No. 520. Undivided back. Postmark: October 1904.)

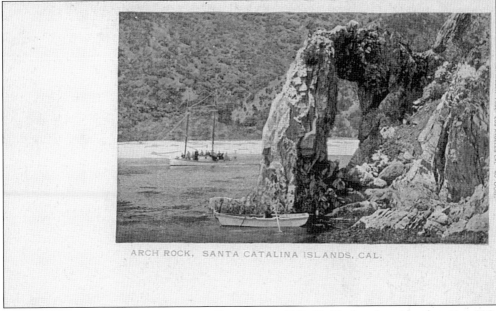

**ARCH ROCK, SANTA CATALINA ISLANDS, CALIFORNIA.** (P/P: M. Rieder, Los Angeles. No. 508. Undivided back.)

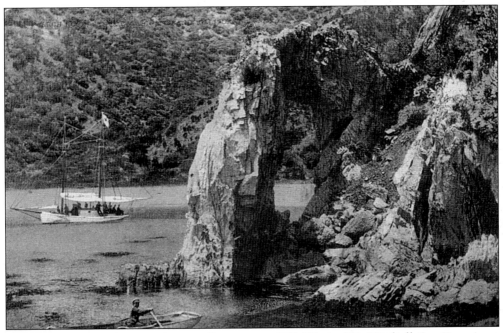

**ARCH ROCK, SANTA CATALINA ISLAND, CALIFORNIA.** (P/P: Edward H. Mitchell, San Francisco. No. 144. Postmark: January 1910.)

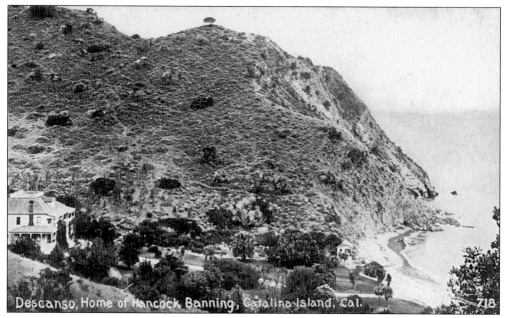

**DESCANSO, HOME OF HANCOCK BANNING, CATALINA ISLAND, CALIFORNIA.** This home was moved farther up the canyon when the St. Catherine Hotel was built in 1895. (P/P: Edward H. Mitchell, San Francisco. No. 718.)

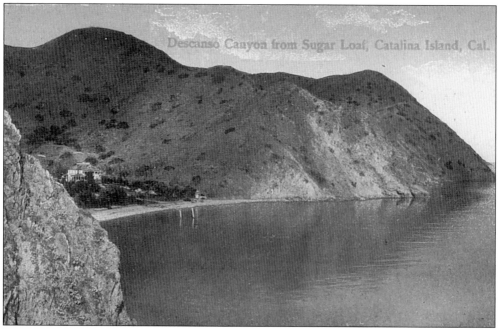

**DESCANSO CANYON FROM SUGAR LOAF, CATALINA ISLAND, CALIFORNIA.** (P/P: M. Rieder, No. 52.)

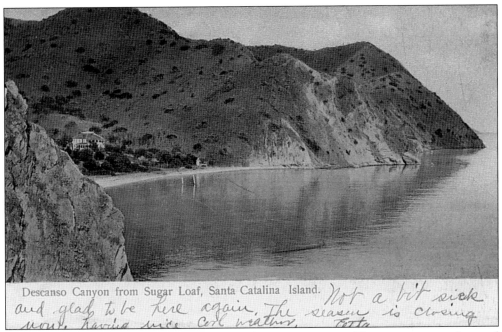

Descanso Canyon from Sugar Loaf, Santa Catalina Island. *Not a bit sick and glad to be here again. The season is closing now. Having nice cool weather. Etta*

**DESCANSO CANYON FROM SUGAR LOAF, SANTA CATALINA ISLAND.** The message on the card reads, "Not a bit sick and glad to be here again. The season is closing now. Having nice cool weather. Etta." (P/P: M. Rieder, Los Angeles and Leipzig. No. 3130. Undivided back. Postmark: August 1909.)

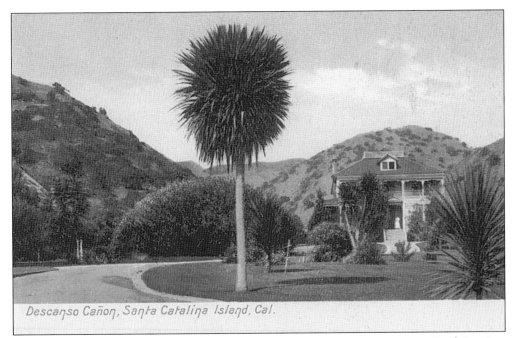

Descanso Cañon, Santa Catalina Island, Cal.

**DESCANSO CANYON, SANTA CATALINA ISLAND, CALIFORNIA.** (P/P: Newman Post Card Co., Los Angeles. No. 4529. Made in Germany.)

113

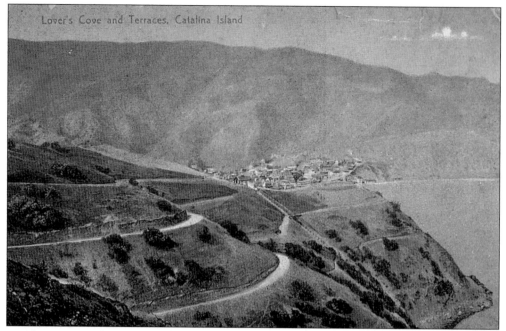

LOVER'S COVE AND TERRACE, CATALINA ISLAND. (P/P: M. Rieder, Los Angeles. No. 9044. Made in Germany. Postmark: November 1907.)

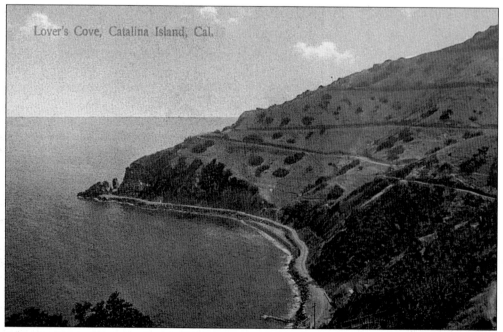

LOVER'S COVE, CATALINA ISLAND, CALIFORNIA. (P/P: M. Rieder, Los Angeles. No. 4762. Made in Germany.)

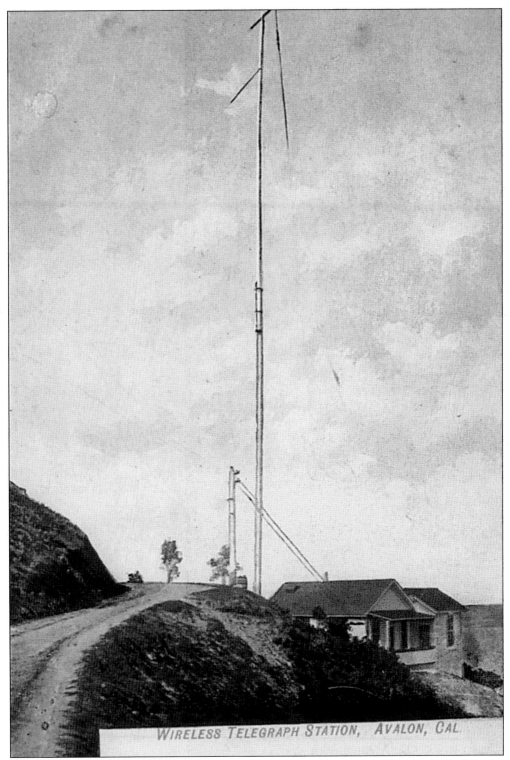

WIRELESS TELEGRAPH STATION, AVALON, CAL.

**WIRELESS TELEGRAPH STATION, AVALON, CALIFORNIA.** (P/P: CEK. No. 679. Undivided back.)

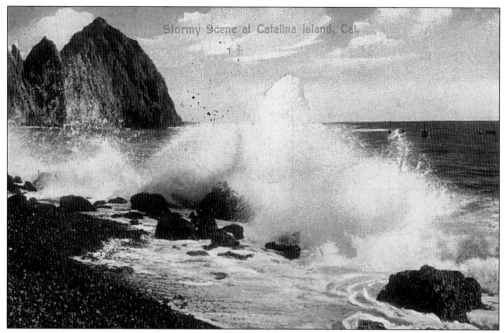

**STORMY SCENE AT CATALINA ISLAND, CALIFORNIA.** (P/P: Newman Post Card Co., Los Angeles. No. E1. Made in Germany. Postmark: November 1908.)

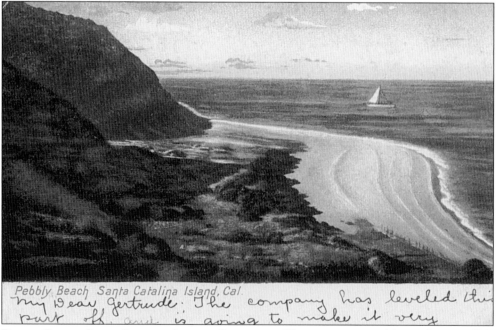

**PEBBLY BEACH, SANTA CATALINA ISLAND, CALIFORNIA.** The message on this card states, "My Dear Gertrude, The company has leveled this part off and is going to make it very attractive." (P/P: Catalina Novelty Co., Avalon. Made in Germany. Postmark: August 1907.)

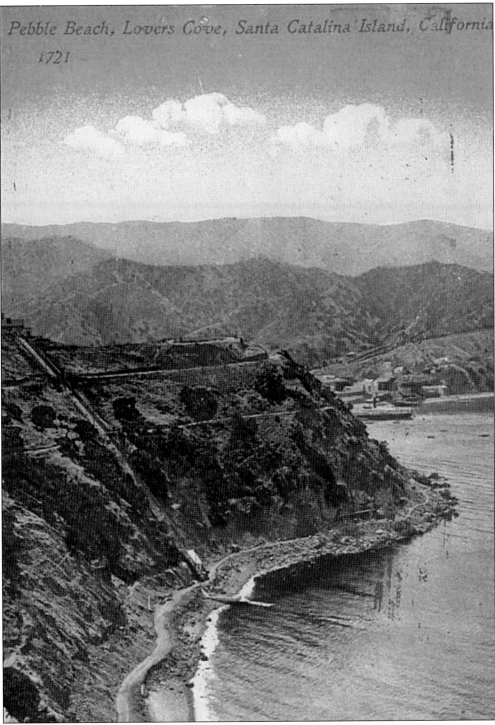

PEBBLE BEACH, LOVER'S COVE, SANTA CATALINA ISLAND, CALIFORNIA. The message on the card reads, "This card will hold all I know in news." (P/P: Edward H. Mitchell, San Francisco. No. 1721. Postmark: August 1920.)

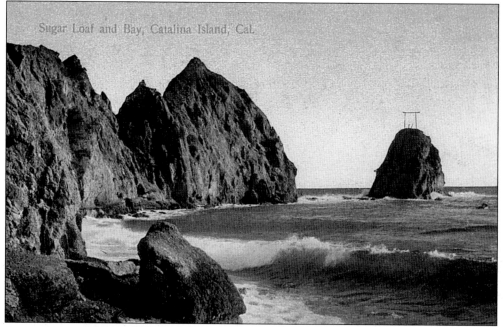

**SUGAR LOAF AND BAY, CATALINA ISLAND, CALIFORNIA.** (P/P: M. Rieder, Los Angeles. No. 3005. Made in Germany.)

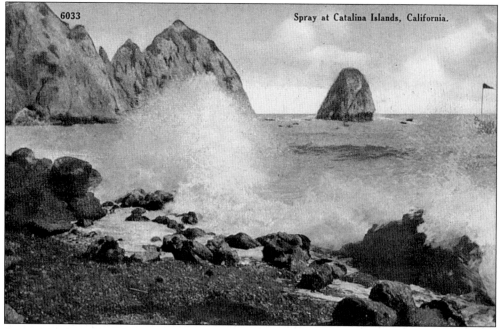

**SPRAY AT CATALINA ISLANDS, CALIFORNIA.** (P/P: Williamson-Haffner Co., Denver. No. 6033.)

118

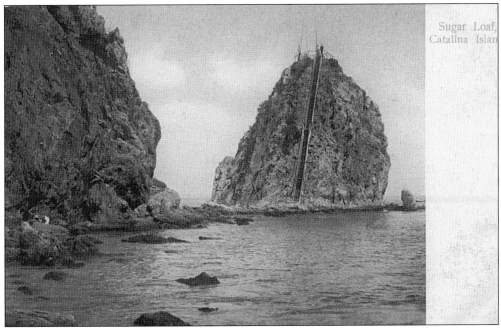

**Sugar Loaf, Catalina Island.** (P/P: M. Rieder, Los Angeles and Leipzig. No. 3393.)

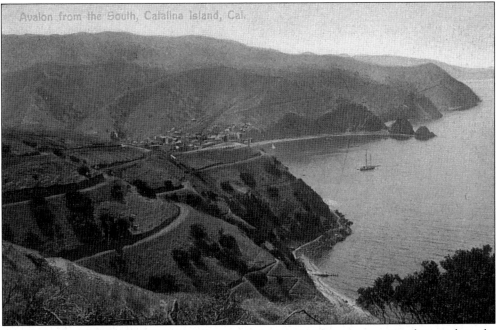

**Avalon from the South, Catalina Island, California.** The message on this card reads, "Arrived here last night from San Diego and will leave in the morning for Santa Barbara." (P/P: Newman Post Card Co., Los Angeles. No. 6139. Made in Germany. Postmark: September 1908.)

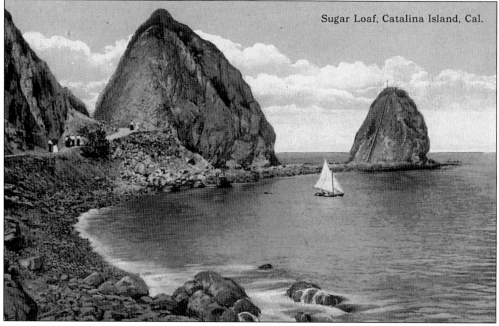

Sugar Loaf, Catalina Island, Cal.

**SUGAR LOAF, CATALINA ISLAND, CALIFORNIA**. (P/P: Catalina Novelty Co., Catalina Island, Cal. No. R51318.)

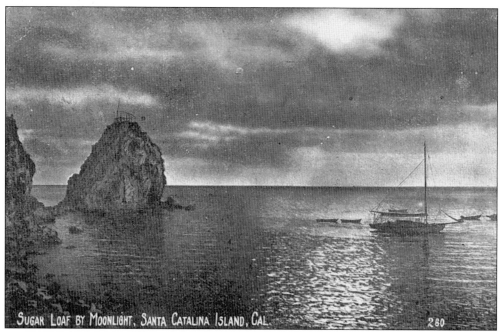

SUGAR LOAF BY MOONLIGHT, SANTA CATALINA ISLAND, CAL. 260

**SUGAR LOAF BY MOONLIGHT, SANTA CATALINA ISLAND, CALIFORNIA**. (P/P: Western Publishing & Novelty Co., Los Angeles. No. 260.)

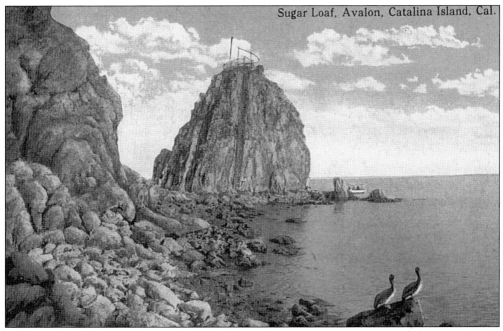

**SUGAR LOAF, AVALON, CATALINA ISLAND, CALIFORNIA.** (P/P: Catalina Novelty Co., Catalina Island, CA. No. R55105.)

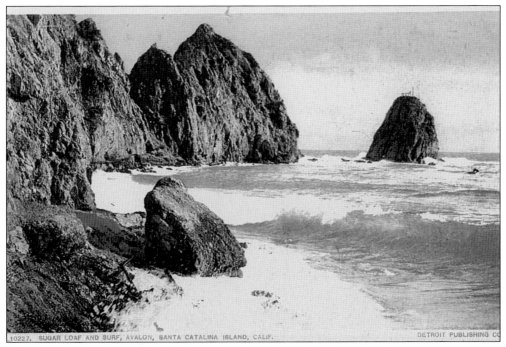

**SUGAR LOAF AND SURF, AVALON, SANTA CATALINA ISLAND, CALIFORNIA.** (P/P: Detroit Publishing Co., No. 10227. Postmark: March 1910.)

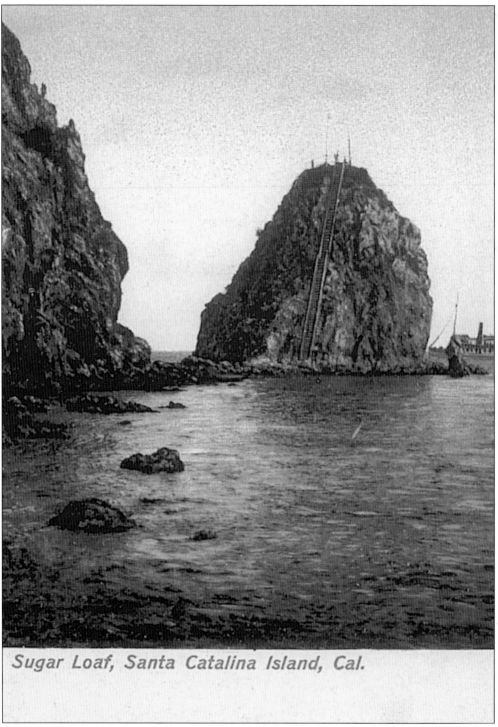

Sugar Loaf, Santa Catalina Island, Cal.

SUGAR LOAF, SANTA CATALINA ISLAND, CALIFORNIA. Big Sugar Loaf (120-feet high) was leveled by blasting powder in 1917. (P/P: Newman Post Card Co., Los Angeles. No. 4530. Printed in Germany.)

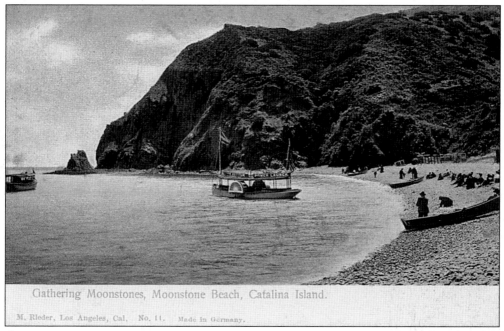

**GATHERING MOONSTONES AT MOONSTONE BEACH, CATALINA ISLAND.** (P/P: M. Rieder, Los Angeles. No. 11. Made in Germany. Undivided back.)

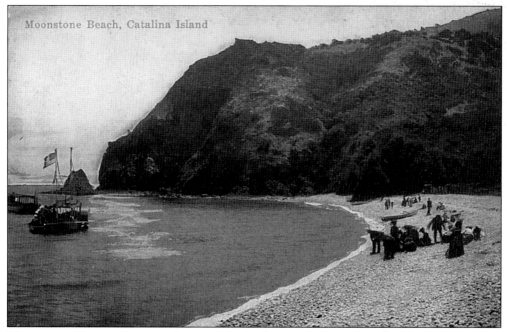

**MOONSTONE BEACH, CATALINA ISLAND.** (P/P: Kashower Co., Los Angeles.)

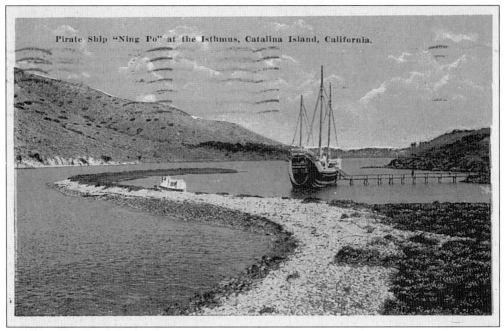

**PIRATE SHIP *NING PO* AT THE ISTHMUS, CATALINA ISLAND, CALIFORNIA.** This Chinese pirate ship washed ashore in Santa Monica in 1912. It was bought by the Meteor Ship Company and taken to Catalina, where it was finally located at Catalina Harbor on the isthmus. (P/P: California Postcard Co., Los Angeles. No. 25223N. Postmark: July 1926.)

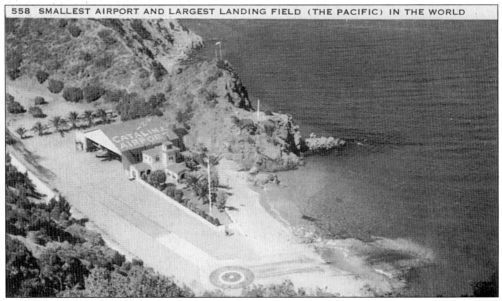

**SMALLEST AIRPORT AND LARGEST LANDING FIELD (THE PACIFIC) IN THE WORLD, SANTA CATALINA ISLAND, CALIFORNIA.** Text on this card states, "In olden days it often took the Indians ten days to travel from Catalina Island to San Gabriel Mission by canoe and oxcart. The same trip may be made today by plane and automobile in two hours." (P/P: Longshaw Card Co., Los Angeles. No. 558.)

124

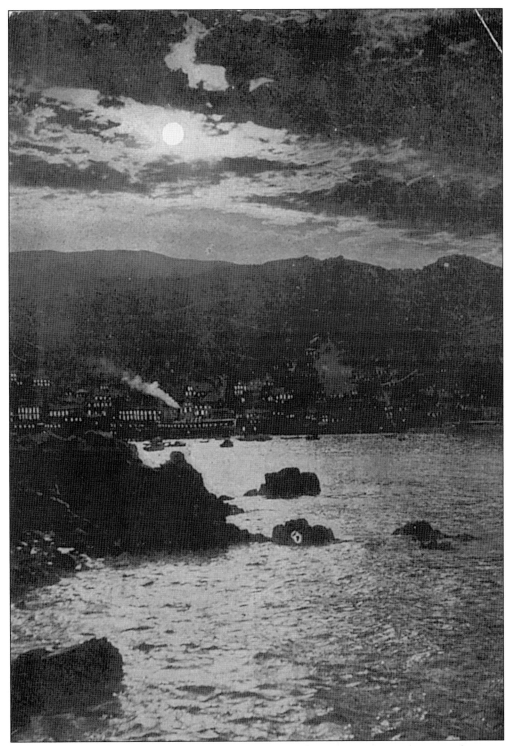

**Moonlight Scene, Avalon Bay, Catalina Island.** (P/P: Benham Co., Los Angeles. No. 2835. Postmark: August 1916.)

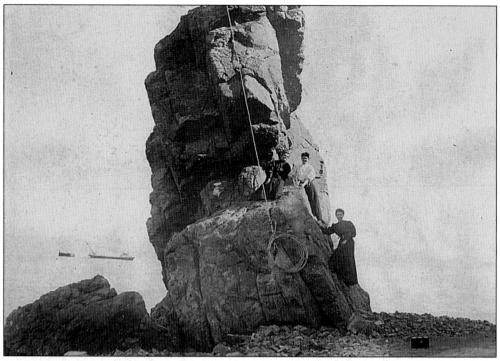

**Rock Climbing on Pebble Beach Catalina Island.** Belva Snively (grandmother of author) and friends are pictured here in 1907–1908. (P/P: Unknown. Private Photo, non-postcard.).

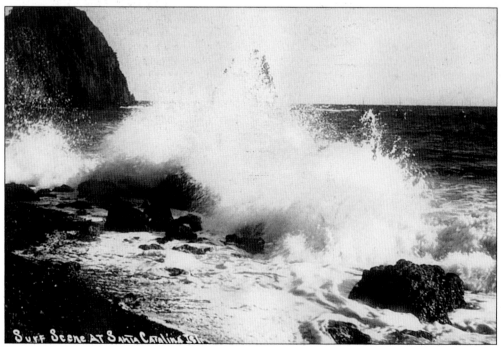

Surf Scene at Santa Catalina Isl.

**Surf Scene at Santa Catalina Isle.** (P/P: Hovey Prints of Southern California, Long Beach. Non-postcard, purchased 1907–08 by Belva Snively [grandmother of author].)

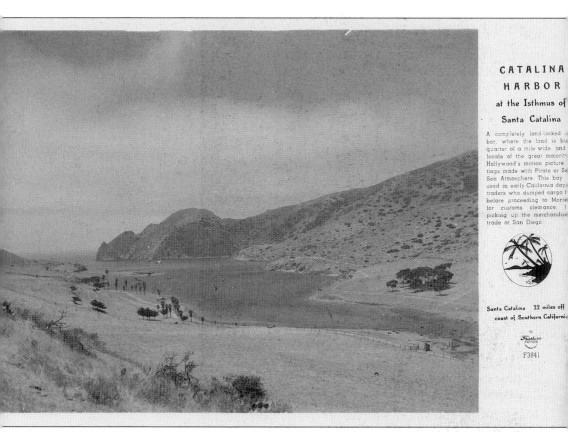

**CATALINA HARBOR AT THE ISTHMUS OF SANTA CATALINA.** Text on the card reads, "A completely land-locked harbor where the land is but a quarter of a mile wide and the locale of the great majority of Hollywood's motion picture settings made with Pirate or South Sea atmosphere. This bay was used in early California days by traders who dumped cargo here before proceeding to Monterey for customs clearance later picking up the cargo to trade at San Diego, Santa Catalina, 22 miles off the coast of Southern California." (P/P: Frasher Fotos, Pomona. No. F3841. Dated 1946.)

# Index of Publishers and Photographers